500

Digital SLR

Hints, Tips, and Techniques

RotoVision

A RotoVision Book
Published and distributed by RotoVision SA
Route Suisse 9, CH-1295 Mies
Switzerland

RotoVision SA, Sales & Editorial Office
Sheridan House, 114 Western Road
Hove BN3 1DD, UK

Tel: +44 (0)1273 72 72 68
Fax: +44 (0)1273 72 72 69
Email: sales@rotovision.com
Web: www.rotovision.com

10 9 8 7 6 5 4 3 2 1

ISBN: 2-940378-06-1
978-2-940378-06-7

Designed by Studio Ink
Art Director: Tony Seddon

Reprographics in Singapore by ProVision (Pte) Ltd.
Tel: +65 6334 7720
Fax: +65 6334 7721

Printed in Singapore by Star Standard Industries (Pte) Ltd.

500

Digital SLR

Hints, Tips, and Techniques

The Easy, All-in-One Guide to Getting
the Best Out of Your Digital SLR

Chris Weston

Contents

Camera setup

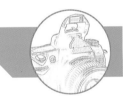

Image quality

Getting ready

Using your DSLR

Flash photography

Useful accessories

Different subjects

Camera care

External devices

Introduction

Even fairly recently, digital single-lens reflex (SLR) cameras were expensive, complicated to use, and produced variable image quality. Today, the world of digital photography has changed immeasurably. Sales of DSLRs (as they are known) are the highest they've ever been, and manufacturers are making cameras that are simple to use, produce great quality images, and don't cost the earth.

Canon and Nikon led the way with groundbreaking cameras that were affordable to consumers. Others swiftly joined in, including Pentax, Olympus, and Sigma. As the "big guns" of the video world (Sony, Panasonic, and so on) extend their partnerships with more traditional photographic names, such as Minolta and Leica, we can expect to see more cameras on the market and further developmental strides, taking digital photography beyond our wildest imaginations.

The result, of course, has been a marked increase in the number of people using digital SLR cameras—from novices through to professionals. And, although many of the "rules" of photography that applied to film are equally important to digital, there are some things that have changed, including new jargon to decipher, and functions and controls to get to grips with, hence the reason for this book. More than a book about digital photography as a whole, *500 Digital SLR Hints, Tips, and Techniques* focuses on the DSLR camera specifically, and will help you to master its workings quickly and begin making pictures that stand out from the crowd.

From the basic controls to an explanation of digital jargon, from setting up the camera to choosing the appropriate accessories, from quickly getting you to understand the basics of white-balance, color spaces, and burst-rate to managing the new phenomenon of digital noise and the more traditional techniques of focus and exposure, here are 500 ways to make life with a DSLR easier.

As with any aspect of photography, however, success isn't solely dependent on your equipment and knowing how to use it. Learning the basics of good composition and strong design across different photographic subjects is equally important, if not more so. Toward the end of the book I have given many tips and techniques that will make photographing your favorite subject easier, whether your passion is for wildlife, landscapes and nature, sport, people, or travel. Throughout each subject-specific topic, not only will you find help to get you shooting better pictures, but also easy-to-follow hints on the most appropriate camera settings for different situations and circumstances.

Of course, taking pictures is only a half of the equation. The other aspect of digital photography is the wide array of uses to which your photographs can be put. And so, this book also throws in some useful ideas and step-by-step guidelines on what to do with your images once they're out of the camera. If you want to print them with the minimal fuss, I tell you how. If you want to play a "slideshow" to friends and family via a TV or VCR, you can. In the world of digital photography, practically anything is possible. But more than anything else, the tips within this book are focused on getting the technique right in camera.

My introduction to the digital SLR camera few years ago with the launch of Nikon's D100 intermediate "prosumer" camera. I was a sceptic at the time, but it didn't take me long to buy into this new and exciting medium for photography. Since then I have owned and used several DSLRs, including the entry-level Nikon D70 and D70s, and Canon 350D, mid-range models such as the Nikon D100, D200, and Konica Minolta Dynax/Maxxum 7D, and the very professional Nikon D2H and D2X, and Canon 1DS Mark II. In that time, my understanding of how to get the most out of a digital camera has grown along with my photography. And what have I done with that knowledge

and experience? Well, along with making a living from selling pictures, I have written it all down in this book. So, I hope that the following pages and chapters will make your enjoyment of digital SLR photography as great as mine.

GALLERY ONE

Get out and about with your DSLR, and really begin to explore the whole world of possibilities its sophisticated functionality and interchangeable lenses can offer you.

From film to digital—making the change

For some people, buying their first DSLR camera is simply a step up from a digital compact camera. Much of the jargon and technology is familiar to them, only the body around which the jargon and technology is concerned is new. For others, the switch is a far greater leap into the unknown, particularly if they have previously owned a film-based SLR. For those people, there are many things that could, without explanation, cloud the issue.

That said, the first thing to realize about digital photography with an SLR camera is that it really isn't that much different to film-based photography. The basic science remains the same: light enters a lens and is recorded by a photosensitive device to produce a permanent image. So what's to know?

The first and perhaps biggest change is the device used to record the image. Film has gone, to be replaced with a digital sensor. Just as there is more than one make and type of film, so there is more than one type of sensor. For most people, however, whether the camera uses a CCD or CMOS device matters little as the results are, to all intents and purposes, much the same. And it's not like you can change from one to another—at least, not without changing camera. An important factor to consider, however, is resolution, and the number of effective pixels on the sensor. Although this is no true gauge to image quality, it is an important aspect and, in very general terms, the greater the number of pixels, the better the image will be.

Another difference worth noting is the role of the camera in all this. There is an old saying relating to film cameras that they are "nothing more than a light-tight box." The same cannot be said for a digital SLR. Digital cameras today are sophisticated pieces of computer equipment. They have all the things a desktop computer has (input device, processor, memory, storage, monitor, and output device connectivity) and, as well as recording light, they also have the technology to digitize, process, and permanently store it.

Other aspects of digital photography are far closer to film-based photography than many might imagine. For example, some may wonder about white balance—a setting that is not found on film cameras. Yet photographers have been managing white balance from the beginning, using film and filters. Now, however, it's far easier and far more accurate. There are other controls that overlap. ISO equivalency is exactly that—the equivalent to film ISO. Tone and saturation can be adjusted in-camera, removing the need for different film types. Burst-rate (the number of images that can be taken consecutively before the shutter locks) is an

important factor when choosing a digital camera, but isn't unique to digital photography. Film cameras have a burst-rate determined by the length of a roll of film. You see, it isn't that dissimilar after all.

Of course, there are some key differences. Film cameras don't need a memory card, but a DSLR does. Choosing the best one is covered in this book. You will also need to understand about file extensions and the difference between JPEG and RAW files. But don't let this put you off–it's not as complicated as it may seem, and everything you need to know should be touched on somewhere in these pages. There are other facets of digital photography that you will need to master: focal length magnification, menus, histograms, and highlights.

I first picked up a digital SLR camera as a professional photographer in 2003. I had never used one before, or even read that much about them. I barely knew the basics. But from the day I started using it, I've hardly put it down–and I've owned four since my first. The truth is, when it comes to doing what we enjoy most–taking pictures–there really isn't that great a difference between the two mediums. Sure, there's a lot of hype, and even more myths, but when you cut through the jargon and get down to the nitty-gritty, the simple fact is, digital photography is still photography.

GALLERY TWO

Your DSLR is capable of capturing bright and vibrant colors with excellent resolution (image quality) and a vibrancy that is persuading more and more professional photographers to let go of film. And the cost-savings can be enormous.

Camera setup

Getting started
It's a good idea to take the time to set your DSLR up properly to get the best out of using it, and to avoid unnecessary problems later on when you're using it on the move.

001 Time and date

It's sensible to set the correct time and, in particular, date information on the camera, so that you have a record of when images were taken. When traveling, you may need to reset the time to local time.

002 Adding comments

Some DSLR cameras have a function that enables you to append a comment to an image or series of images. For professionals, this can be useful for adding a copyright notice to image files. For hobbyists, this function is an excellent means of adding other useful information, such as where the picture was taken, or the occasion.

003 Remember!

Remember to switch off the comment function or to update it with new information when circumstances, such as location, change. Otherwise, you'll have comments appended that don't match your image files.

004 Always check your manual

To learn how to set time and date information, and to add image comments to a photograph, check your user manual, as the methods vary between different camera models and makes.

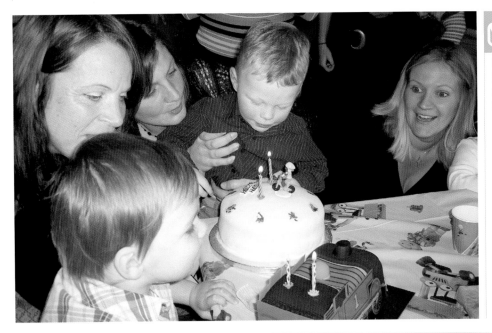

Batteries and battery life

005 Battery type

The lithium-type batteries used by many DSLR cameras have a longer life than cell batteries. Where your camera offers an option, opt for the former.

006 Charge it

Ensure you fully charge the battery the day before you go on a shoot. Always have a spare, fully charged battery to hand on lengthy shoots.

007 Battery life

Battery life is dependent on the age and condition of the battery, temperature, and how the camera is used. While it's possible to achieve the manufacturer's test figures in laboratory conditions, it's unlikely you'll get anywhere near as many shots in reality. To increase battery life, follow battery usage instructions closely, and keep batteries warm where possible.

008 Switch off unused features

Turn off any features that you don't necessarily need, such as the automatic preview function. This will help maximize the battery's life.

009 Conserve power

Another way to conserve battery power on lengthy shoots is to switch off the camera when it is not in use.

010 Recharging batteries on the move

If you photograph outdoors a lot, a useful piece of equipment is an inverter. This plugs into the 12V socket used for the cigarette lighter in your car, and enables you to charge batteries on the move via the main charger.

Memory devices

One of the main differences between digital and film cameras is the storage media on which all of your images can be stored—usually, this is in the form of a removable card. So what are the options, and the implications of each?

Setting transfer mode

If you expect to transfer your captured images from the memory device to a computer, then you should select Mass Storage or Data Storage as the transfer mode (in the menu options). This tends to be the default setting in most DSLRs. If, however, you expect to print directly from the camera using PictBridge technology, then you should select PTP as the transfer mode.

012 What do memory cards do?

After you take a photograph, the camera converts the light signals into digital data and, depending on the file type, processes the information before transferring it onto a memory device inserted in the camera body. The purpose of the memory device is to provide semipermanent storage of images until they can be downloaded to a computer's hard-disk drive or other form of long-term storage media, such as a DVD or portable hard disk.

013 Computer link

It's possible with some DSLR cameras to download images straight to a computer hard drive as you take them. Typically, this type of usage is restricted to studio photography because the camera may need to be "tethered" to the computer, although some more advanced DSLRs now have wireless functionality.

014 Understanding the terminology

Memory cards are often referred to as "digital film," a term that is misleading as these devices are not light-sensitive, have no light-recording capability, and play no part in image capture. The only property they share with film is the ability to store a captured image. In reality, the photo sensor is the closest equivalent to film.

Types of memory device

015 Comparing your options

The two most popular forms of storage media used are the CompactFlash (CF) card and the MicroDrive. MicroDrives consist of a miniature hard-disk drive and were initially aimed at the professional market because of their high-speed/high-capacity features. With the advances that have been made in CompactFlash card design, however, the benefits that once sold the MicroDrive now seem a little outdated. Their main advantage now is cost per megabyte value, which is typically better than equivalent capacity CompactFlash cards.

016 Secure Digital (SD)

A third option becoming available to DSLR users is the SD (Secure Digital) card. Smaller and lighter than either CF cards or MicroDrives, they are heralded as the future of in-camera storage.

017 MicroDrives and reliability

A CompactFlash or Secure Digital card is more reliable than a MicroDrive. As the latter is a miniature hard-disk drive, it contains moving parts that are prone to wear and tear, making it vulnerable to heavy-duty usage and fieldwork.

018 CompactFlash (CF) cards

CF cards are less problematic than MicroDrives because they use solid-state technology, which means they have no moving parts. This makes them less susceptible to excessive heat generation and increased power usage. Price might be a consideration depending on card size. Lower-capacity cards (e.g. 1GB) compete on price with both MicroDrives and SD cards. At greater capacities (e.g. 4GB), a CF card can be more than twice the price of a MicroDrive.

019 Type I and Type II cards— what's the difference?

CF cards are available in two physical sizes, referred to as Type I and Type II. Type II cards are thicker. While practically all current digital cameras accept both card types, some earlier models accept only the thinner Type I device. The main difference between them is capacity. In general, Type II cards have a greater capacity than Type I cards.

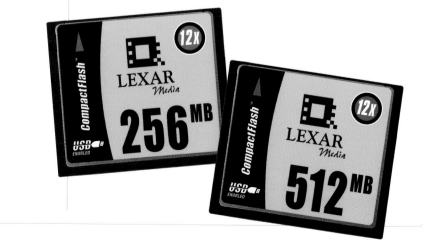

Memory

020 Consumer versus professional cards

Most manufacturers of CF cards have two variants, one for the consumer market and one for the professional market. The main difference is in the write-speed (the speed at which data are transferred), the latter having faster data-transfer speeds. When frame-rate and burst-depth are critical, higher write-speeds are an advantage. However, most users will find the standard card types perfectly adequate for their needs—and considerably less expensive.

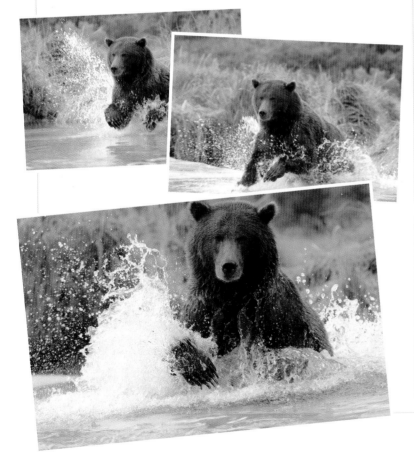

021 Card capacity and write-speed

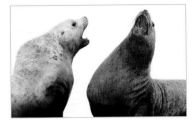

The capacity and speed of memory devices are changing constantly. At the time of writing, CF cards are available in capacities from 32MB (very small) to 8GB (very large), and with write-speeds ranging from about 10x to more than 100x. The greater the capacity, the more images the card can hold. And the quicker the write-speed, the faster the data are transferred from the camera's internal memory to the card, which can increase burst-depth.

However, some of the larger-capacity, fast write-speed cards require your camera to support Lexar Media's Write Acceleration (WA) and FAT32 technologies. (You'll need to refer to the manufacturer's specifications to check whether this applies to your camera.)

022 Capacity—is there an ideal?

This question boils down to two main issues: manageability and reliability. With a 6-megapixel DSLR, it is possible to store more than 2,500 images on an 8GB memory card (depending on the file type). If the card were to fail or become lost, that's a lot of photographs to lose.

Your decision may also be influenced by the type of photography you do. For example, when photographing action, such as sports or wildlife, you may find that switching cards is inconvenient and that higher-capacity cards enable fewer card changeovers. This may be less of an issue for less time-sensitive subjects, such as still life and studio photography.

023 Data-transfer speeds for CF cards

Card speed	Data-transfer speed (megabytes per second)
8x	1.2
12x	1.8
20x	3.0
25x	3.8
30x	4.5
40x	6.0
60x	9.0
66x	10.0
80x	12.0

024 Capacity of memory devices

025 Using memory cards

The first time you use a new memory card, you should format it, which is usually done via a camera menu option (refer to your user guide).

026 Deleting files from the memory card

You can erase unwanted images from the memory card as you go along, freeing capacity. The only time you shouldn't remove the card from a camera or other device is when the camera's computer is accessing the card. Always refer to the Access Indicator lights to tell you if it is safe to remove the card.

027 Taking memory cards through airport X-ray machines

Unlike film, memory cards are unaffected by the X-ray machines used for checking hand luggage and the more powerful ones used by airport authorities to scan baggage placed in the hold.

Approximate number of images stored per device

Sensor size (Megapixel)	File size (MB)	32MB	64MB	128MB	256MB	512MB	1GB	2GB	4GB
2	0.9	35	71	142	284	568	1137	2275	4551
3	1.2	26	53	106	213	426	853	1706	3413
4	2.0	16	32	64	128	256	512	1024	2048
5	2.5	12	25	51	102	204	409	819	1638
6	3.2	10	20	40	80	160	320	640	1280

The figures given here are approximate and refer to fine-resolution JPEGs. Figures will vary for other image-quality settings.

Image playback

028 Review only what you need to

Set the camera so that the auto-image playback is switched off. This will help conserve the life of your batteries.

029 Viewing in bright conditions

Purpose-made screen shades that help viewing images on the LCD monitor in bright sunlight are available. However, save your money and carry with you the cardboard tube from a roll of toilet paper, which works just as well.

030 Auto-rotate

Some cameras have a useful function, set via the menu options, that automatically rotates images shot in vertical format to display in the correct orientation when viewed on the LCD monitor or via an external computer. Check your user manual to see if your camera has such a function and, if so, switch it on.

031 What you see isn't really what you get

Don't be fooled into thinking that it's possible to make critical editing adjustments using the LCD monitor. While this screen is useful for checking compositional strength and, via the histogram and highlights screen, exposure to a certain extent, it is less precise when reviewing other qualities, such as color and image sharpness. Always do your final editing with a desktop or laptop computer.

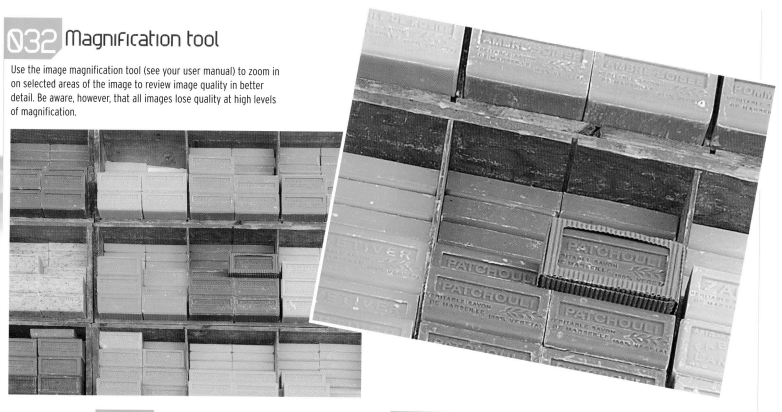

032 Magnification tool

Use the image magnification tool (see your user manual) to zoom in on selected areas of the image to review image quality in better detail. Be aware, however, that all images lose quality at high levels of magnification.

033 Watch the highlights

I have found the most useful playback screen to be the highlights screen, which identifies areas of the image where the highlights (whites) have burned out beyond the dynamic range of the sensor.

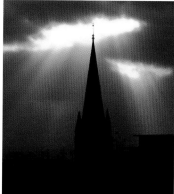
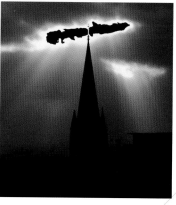

Managing images in-camera

034 Creating user-defined folders

All image files created by a DSLR are kept in a folder, usually a default folder named by the camera. Some DSLRs have a function enabling you to create your own folders in which to save images, with user-defined names. This is a very useful feature, particularly if you use the camera infrequently and have images from several different events or shoots on one memory card. For example, you could name one folder "Birthday party," another "Christmas," and a third "New Year party," and save the images taken on each of those occasions to their respective folders. This makes sorting, showing, and retrieving images at a later date far easier.

036 Under lock and key

If you've managed to grab a shot to remember, then use the Image Protect key to prevent accidental erasure of the image. Refer to your user manual to locate this.

035 Edit as you shoot

While I don't recommend doing final edits in-camera, it is possible to identify on the LCD screen any poor images during image playback. Those images, for example, where the head of your subject has been cut out of frame, or where you forgot to focus the camera correctly, should be deleted as you go. It will save you time in front of the computer when you return home.

037 Camera menus

All digital cameras have a plethora of menus with various features and functions that change or adjust the way your camera operates. Spend time getting to know the more relevant ones (highlighted throughout this book with the [symbol] key) so that you can find and use them quickly.

038 Saving menu settings

Some DSLRs have a facility that enables you to save custom menu settings for specific shooting situations, so you can quickly revert to your preferred settings when photographing specific subjects, such as Setting A for wildlife and Setting B for people. Using these custom presets will save you considerable time in the field—and improve your photographs.

Image Quality

Getting the best

The manner in which digital cameras are marketed would have you think that megapixels are the only factor in image quality. Not so. File type, compression, image size, and numerous other in-camera settings will all affect the quality of the image that is finally stored on the memory card. The following advice will help you to define the level of quality you need and how to achieve it.

039 What are pixels?

A digital sensor is an array of photodiodes laid out in a grid pattern. Simply put, these create pixels (picture elements) and, in very general terms, the greater the number of pixels, the higher the image resolution.

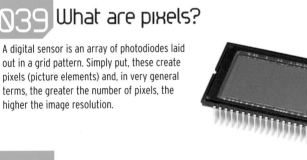

040 What is resolution?

Resolution is the measure of the total number of pixels on the sensor (width x height). For example, an image sensor measuring 3,072 pixels across x 2,048 pixels high has a resolution of 6,291,456 pixels, more commonly referred to as 6.2 megapixels.

041 Resolution and image quality

It makes sense that a sensor with 6.2 million "points" for capturing light will produce a better image than a sensor with, say, half the capability. In basic terms, this is true. However, because an element of image quality is dependent on how many of those pixels are used for image capture (effective pixels), as well as a number of varying parameters, such as their size, shape, and configuration, the world of digital resolution is less simple than that.

042 Dynamic range and image quality

Photodiodes are sensitive only to a certain range of brightness levels (known as the sensor's dynamic range), and this range varies between sensors from different manufacturers. The higher the dynamic range, the greater the amount of information that can be captured. Therefore, it's feasible that a camera with a lower number of total pixels than another can sometimes have a higher resolution.

043 Pixels and picture use

What is important is the number of pixels you actually need, and that depends on what you intend to do with the photograph. For use only on a Web site or for small prints for a scrapbook, say, then resolution is less important. For prints and professional publication, high resolution is very important.

3 x 2

6 x 4

7 x 5

044 Resolution and print size

The following table provides a quick reference for resolution requirements when printing:

Minimum resolution for print size

Print size (in)	Minimum pixel dimensions
3 x 2	600 x 400
6 x 4	800 x 600
7 x 5	1,400 x 1,000
10 x 8	2,000 x 1,600

10 x 8

045 Total pixels and effective pixels?

Camera manufacturers usually provide two pixel counts with their marketing blurb: total pixels and effective pixels. When determining image resolution, only effective pixels are relevant, and provide a more accurate indication of image resolution. This is because some of the pixels on a sensor are used for tasks other than recording brightness levels.

046 Setting image size

In general terms, the larger the size of the image the better, remembering that it's always possible to reduce file size but never to increase it without compromising image quality. When shooting in JPEG mode, your camera will typically give three file-size options—small, medium, and large.

047 Medium and small file sizes

The advantage of selecting a size other than large is that it reduces the amount of space the image takes up on the memory card. It may also increase burst-rate. The significant disadvantage is that it greatly reduces image quality. If the images are intended for quick transmission via the Internet, and quality is of little concern, then a small image size may be acceptable.

048 Large file sizes

If you intend to print your images at anything beyond postcard size, or to use your images professionally, then you will want to select a large image size.

049 Selecting the file type

DSLRs can save images as either JPEG files or RAW files (some cameras have a TIFF file type as well). Which type is better for your photography depends largely on what you plan to do with the pictures afterward.

050 JPEG files

A JPEG file is a processed image file. The camera takes the raw data from the sensor and then processes the image as per the camera settings (e.g. color space, white balance, sharpening, etc.). To conserve space, the camera then compresses the data to a quality defined by the user (high, medium, or low), and then saves the processed, compressed file to the memory card with a unique name and JPEG extension, such as NIK0010.jpeg.

051 RAW files

RAW files are saved unprocessed by the camera. The camera makes a note of the settings applied at the time the image was taken and attaches this "note" to the raw data. It then saves the image either compressed (using lossless compression technology) or uncompressed to the memory card with a unique name and RAW extension (which is specific to the manufacturer), such as NIK0010.nef (NEF is Nikon's proprietary RAW extension name).

Advantages of shooting in RAW mode

052 Unprocessed work

Having a RAW file is the equivalent of having exposed but unprocessed film. It holds only the data captured at the scene without any other variables applied, which means you can use different processing techniques as frequently as you like, taking advantage of new and improved software applications as they're developed.

053 Later adjustments

Shooting parameters such as white balance (WB), sharpening, saturation, etc., can be adjusted after the picture has been taken, as though they were set at the time of shooting, which minimizes the likelihood of image degradation. It's a little like having the ability to retrace your steps and reshoot the scene as often as you like. Arguably, these parameters can also be adjusted on a JPEG file, but alterations cannot be made with the same accuracy and exactness.

054 Color conversion

Color conversion is done in-computer (using more sophisticated algorithms than the camera's built-in processors can handle), which improves image quality.

055 16-bit mode

RAW files take advantage of the full 16-bit mode in-computer, giving a total of 65,536 brightness levels to work with, as opposed to just 256 with a JPEG file. This makes post-camera processing a far more expansive application and gives you greater image-processing options than are available with JPEGs.

056 RAW to JPEG

You can create a JPEG file from a RAW file, but you can't create a RAW file from a JPEG. Similarly, you can compress a large file to make it smaller, but once the JPEG algorithms have discarded their data, you can never be sure of recreating it exactly.

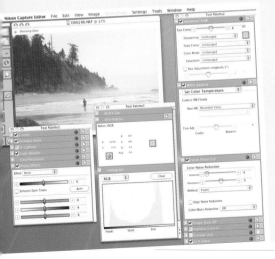

Advantages of shooting in JPEG mode

057 Formats and file sizes

JPEGs produce much smaller files, hence more can be shot per memory card. For example, a 512MB card will store about 222 high-resolution, or 1300 low-resolution JPEGs, compared to just 79 RAW images. Similarly, the burst-rate is affected. You could shoot 40 consecutive high-resolution JPEGs and only 25 RAW images on the same camera—a loss of well over one-third in productivity.

058 JPEG versus RAW

While you can argue the limitations of JPEG-processing algorithms, the reality is that there is very little visible difference between a high-resolution JPEG (referred to as a FINE JPEG both in Nikon and Canon) and a RAW file for most uses.

059 Online service

Because JPEG files are smaller in size, they can be transmitted more easily over the Internet or a computer network.

060 On JPEG time

Because JPEG files are processed in-camera, you can produce finished images of high quality before downloading them to a computer, which makes post-camera processing less necessary. So, if you prefer to spend time taking pictures in the field, then JPEGs will help reduce the time you need to spend in front of a computer.

061 Image-editing software

JPEGs can be opened in practically any graphics software application, which negates the need for the proprietary software supplied by the camera's manufacturer. This can save time in the digital workflow because it removes one stage from the overall process.

062 RAW versus JPEG

Many DSLRs now have a function that enables you to capture both RAW and JPEG images simultaneously. This has the advantage that you get to have your cake and eat it, with regard to speed versus quality. However, the disadvantage is that you increase the overall file size, which reduces the effective capacity of the memory card.

063 Speed versus quality

At the end of the day, whether you shoot RAW or JPEG files comes down to the final application. If image quality is less important than speed of delivery, then shoot JPEG. If image quality is everything, then shoot RAW. If in doubt, and if your model of camera supports it, shoot in RAW+JPEG mode, and you have the best of both worlds.

 +

064 TIFF images

Some cameras support the TIFF file extension. TIFF files, like JPEGs, are processed in-camera and so have none of the advantages of RAW files. They are also very large files, so lack the size advantage of JPEGs. The one advantage they do share with the RAW image is that any compression applied is lossless. However, there are few applications that would require you to shoot TIFF in-camera.

065 Converting RAW files

Eventually, all RAW files have to be converted into a more standard file type, such as TIFF or JPEG. All RAW files have a proprietary extension (Nikon=NEF; Canon=CRW), which determines the code used when constructing a RAW file. Because this code is unique to a particular manufacturer, generally the file must be opened in that manufacturer's proprietary software. For example, Nikon RAW NEF files must be opened in Nikon View or Nikon Capture software. It's fair to say that some of these applications are less than ideal for image-processing, and sometimes vary from camera to camera, making standardization of your workflow impossible.

066 Generic RAW conversion software

There are some generic image-processing applications that include RAW file converters, or translators, that allow RAW files to be opened independently from the proprietary software. For example, Photoshop contains translators that allow RAW files to be opened directly within the application.

File compression

 JPEG compression

When a file is compressed using JPEG compression, algorithms are used to reduce the physical size of the image file (in bytes). Once the file is compressed, some original data are discarded permanently. When the file is opened, algorithms are again used to reconstruct the image, with the missing data replaced with simulated pixels, often resulting in a loss of image quality.

 Resaving JPEG files

Every time you resave a JPEG file it is further compressed. Eventually, if resaved over and over, there will be little left of the original data. If you plan on regularly processing the same image, then it is better to save the image as a TIFF file.

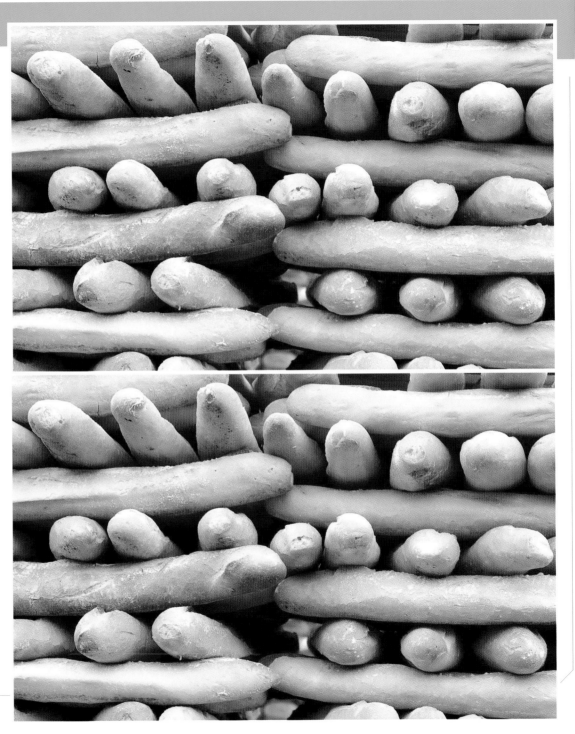

FINE = 1:16 (1 pixel in 16)

NORMAL = 1:8 (1 pixel in 8)

BASIC = 1:4 (1 pixel in 4)

069 Reducing the negative effects of JPEG compression

Typically, there are three levels of in-camera JPEG compression–FINE, NORMAL, and BASIC. The compression ratios used in each are roughly as follows:

FINE = 1:16 (1 pixel in 16)
NORMAL = 1:8 (1 pixel in 8)
BASIC = 1:4 (1 pixel in 4)

070 RAW (and TIFF) compression

Lossless compression, as applied to RAW and TIFF files, compresses the data to reduce the file size but retains all the original data. When the file is retrieved, the computer reconstructs the image with exactly the same data that it started with, and image quality is maintained at the original level.

071 Other effects of compression

In some camera models, applying file compression in-camera can significantly slow down the processing time, which in turn adversely affects the burst-rate. In others, compression actually speeds up the processing of images between the internal memory and the memory card.

Getting ready

In-camera creativity

Digital cameras, and DSLRs in particular, have a number of settings that affect the manner in which the image is recorded and processed. It is a prerequisite of some of these functions that they are set in-camera, while others can be selected in-camera or adjusted later in-computer. However, our aim as photographers should always be to get the image as close to perfect as possible in-camera, reducing the amount of post-capture work needed.

072 Setting the shooting mode

DSLRs have two or more shooting modes—that is, the number of frames exposed during a single press of the shutter release. Depending on the level of sophistication of the camera, these typically include single-frame advance, continuous-frame advance (often with two speed settings—low and high), and some form of self-timer function.

073 Set shooting mode to suit the situation

If your subject doesn't demand continuous-frame advance, then don't use it. Taking long bursts of near-identical exposures simply fills capacity and leaves you with added editing work later on.

074 When to use single-frame advance

Stationary subjects, such as still lifes, certain forms of macro photography, and landscapes, rarely require multiple-frame advances. Set the shooting mode to single frame.

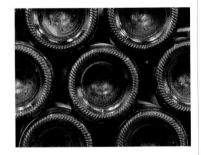

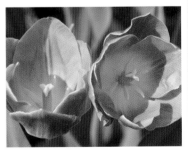

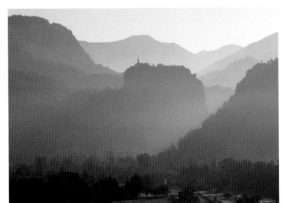

075 When to use continuous-frame advance

If your subject is moving or in a dynamic environment, such as during a high-speed sporting event (e.g. motor racing), then selecting continuous-frame advance will help to ensure you don't miss any of the action.

076 Avoid shutter lock-out

If your camera has low- and high-speed options, be wary of the latter. There are few subjects that require eight-frames-per-second advance speeds, and you're liable to lock the shutter by quickly filling the buffer memory. You're also likely to end up with several near-identical images.

077 Using the self-timer release

When the self-timer release is set the camera will automatically activate the shutter after a delay of a preset duration. This function is useful if you want to put yourself in the picture (make sure to set the timer to allow yourself enough time to get in position). It is also an alternative method of firing the shutter without causing the camera to vibrate when the camera is attached to a tripod and you've forgotten the cable release.

078 Remember!

If you select the self-timer, then do remember to deselect it once you've finished. Otherwise, the next time you press the shutter, you'll be left wondering why it doesn't activate immediately.

079 Color space

For different renditions of color, photographers using film choose different film stock—for example, Fuji Velvia for punchy, saturated colors, or Kodak Portra for accurate skin tones. To a lesser extent you can make similar selections with your DSLR by altering the color space in the menu options (see your user manual).

080 sRGB color space

The exact settings vary between camera makes and models. Typically, the different color space options will be labeled sRGB. In Nikon cameras, sRGB I is suitable for photographing people, and sRGB III is better for nature and landscapes.

081 Color space for Photoshop

If you intend to do a lot of post-capture processing work on a computer, then set the Adobe RGB color-space setting. This setting has a wider gamut of colors than sRGB settings, giving you a greater range to work on in Photoshop (or similar image-processing software packages).

082 Sharpening

All files produced by a digital camera require sharpening. The question is whether to apply the sharpening before or after capture. If you want to place your work with a photo library, you will not want to apply in-camera sharpening. This is because agencies prefer to apply sharpening specifically for individual clients. Otherwise, in-camera sharpening is effective.

083 Sharpening settings for different subjects

If your subjects are people, set a medium level of sharpening. Subjects where texture forms an integral part, such as ice crystals, animal fur, and tree bark, will benefit from additional sharpening but not at the highest level. For a soft-focus effect, apply little or no sharpening

084 Sharpening and focus

Don't be fooled into thinking that sharpening is a substitute for focusing—it isn't. An out-of-focus image is out of focus, and no amount of sharpening will change that.

Dealing with scene contrast

085 Tone

The tone setting adjusts the level of contrast, extending it to make it more pronounced, or reducing it to produce a softer image. For example, when photographing a medium-tone subject in flat lighting, you may want to set tone to a high level to increase the amount of contrast to add depth to the scene. Conversely, in very bright conditions, reducing the tone to a low level will reduce the range of tones between the highlight and shadow areas, giving the subject a softer appearance. An example of this would be photographing a person in bright sunlight.

087 Recovering data

If you lose data held on the memory card (e.g. caused by a faulty card or accidental deletion) it can be recovered using software such as SanDisk's RescuePro data-recovery application. This type of software is generally non-proprietary and will work with different card makes and formats.

086 Check for tonality using the histogram

The histogram is a graphic representation of the range of tones recorded for an image by the sensor. Use it to determine the level of contrast present in the scene and set the tone control accordingly:

Scene lacks contrast: increase tone level; Contrast too rich: reduce tone level. (Compare monochrome images top right.)

Capturing the best image

If you want to print your images direct from the camera with very little or no image processing post-capture, then learn the following guidelines to help you to set up the camera accordingly.

088 Photographing people

Color space = sRGB I (natural skin tones);
Sharpening = normal (medium level);
Tone = normal (medium level) in average light, or slightly less than normal in bright conditions.

089 Photographing outdoor subjects (e.g. sport, nature, and landscapes)

Color space: sRGB III (saturated colors);
Sharpening: slightly above normal but not the highest setting;
Tone: normal (medium level) in bright conditions, or more than normal in average light.

090 Recommended settings for Photoshop processing

If you plan to work on your images post-capture then the following settings are a useful guide.

Color space: Adobe RGB;
Sharpening: none (apply in computer);
Tone: normal.

091 White balance

Our eyes automatically compensate for variances in the color temperature of light and we see all light as indistinguishable in color cast. For example, to us the color of the light emitted by a bedside lamp looks the same as sunlight. In reality, however, it isn't. Digital sensors record the color casts associated with color temperatures with less latitude and, theoretically, greater accuracy. In other words they record the light that our eyes don't see. Therefore sensors need to be balanced to return the same neutral, white light that we see with our eyes. The white balance (WB) setting on your DSLR manages this balancing act in the same way that color correction (CC) filters fulfilled the role for film.

092 Kelvin scale

The color temperature of light is measured using the Kelvin (K) scale. Noon sunlight on a clear summer day, for example, has a value around 6,000K. However, on the same summer day the temperature of light around the time of sunset is only about 2,000K—far warmer than the bluer midday light.

093 Color temperature table

The following table provides an outline of color temperatures under different lighting conditions.

Light source	Color temperature
Candle	1,000K
Early sunrise	2,000K
Low-effect tungsten bulbs	2,500K
Household lightbulb	3,000K
Studio photo floodlights	4,000K
Typical daylight, electronic camera flash	5,500K
Midday sunlight	6,000K
Bright sunshine on a clear day	7,000K
Slightly overcast sky	8,000K
Hazy sky	9,000K
Open shade on a clear day	10,000K
Heavily overcast sky	11,000K

094 How to use the WB setting

To create natural-looking images, you must match the WB value set in the camera to that of the lighting conditions. For example, if you're taking a photograph of children playing during a party, indoors under normal household artificial light, then to avoid the carrot-like orange cast typical of such settings, select a WB value similar to that of the lightbulb—about 2,500-3,000K.

When to use which preprogrammed WB setting

095 Auto WB

The camera will measure the color temperature of ambient light and set a WB value to produce a natural-looking image. Use this setting for general photography.

097 Fluorescent

The fluorescent setting will apply when photographing scenes lit by fluorescent strip lights (such as those found in many household kitchens) or other forms of fluorescent lighting, including some types of studio lighting and the lighting found at sports stadiums.

096 Incandescent (or tungsten)

The incandescent setting should be used when the light source is a general household lightbulb, or similar—for example, when photographing an indoor party at home. Some types of studio lighting are also incandescent (otherwise known as tungsten light).

098 Direct sunlight

Use this setting when photographing outdoors on a bright, clear day during the middle of the day. This setting is perhaps the closest to the standard Kelvin rating of daylight-balanced film.

 Flash

Light from a flash unit in terms of color temperature is close to natural daylight (around 5,500K). However, you should use this setting when using flash, either on-camera or in the studio, and where flash is the main source of light.

 Cloudy

Clouds scatter light and reduce the color temperature of light. Use this setting on an overcast day.

 Shade

When your subject is in deep shadow, use the shade setting to give more natural-looking results.

 Presetting WB

If you are photographing in a location where the lighting conditions are fixed, such as in a sports arena under floodlighting, then it is possible to preset the WB value. Refer to your camera's user manual for details on how to do this.

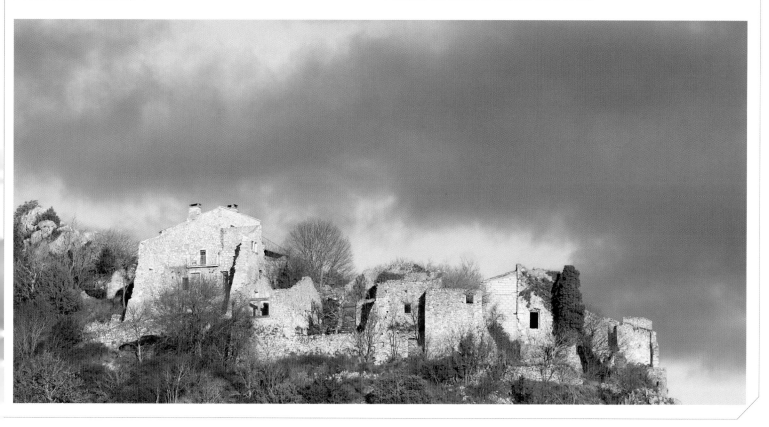

103 Replicating the effects of warming filters with WB

You can replicate the effects of using a warming filter by using your camera's WB settings. For example, selecting the cloudy preprogrammed WB setting produces a similar effect to adding an 81A-warming filter in front of the lens. Similarly, the shade setting will produce an effect similar to a stronger 81C-warming filter.

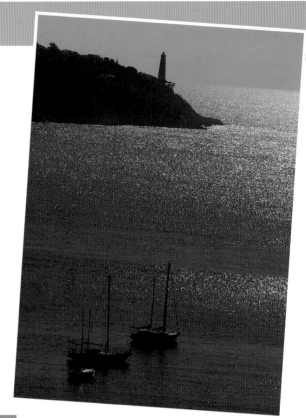

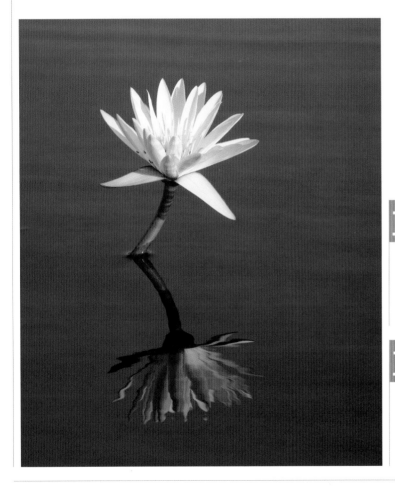

104 Replicating the effects of a blue filter

To replicate the effects of a blue filter, set the WB to the fluorescent setting. You may need to experiment a little before you get a result you are happy with.

105 Going beyond WB basics

The preprogrammed WB values are useful tools, and are a quick and easy means of achieving reasonable results. However, it's possible to achieve more accurate results if you set WB according to the actual prevailing conditions. Most DSLRs have a Preset option, while others also enable you to set specific Kelvin values in small increments. Using either option, you'll need to measure the color temperature of the light source prior to taking the picture.

109 ISO-E and grain

A significant difference between film and digital is the lack of film grain. To increase the sensitivity of a digital sensor, the signal created by the photodiode is amplified electronically by the camera's computer. Grain, therefore, is never present, but the sensor will be affected by increased digital noise (randomly appearing, unrelated pixels) at higher amplifications.

106 Using color temperature artistically

You can set the mood and influence the way a photograph is perceived emotionally by using WB effectively. For example, landscape and wildlife images often look more appealing when the color temperature of the light is biased toward the warmer Kelvin values (e.g. about 3,000K). Snow and ice, on the other hand, look more attractive when they are seen under cooler conditions that are more representative of their physical state. Portraits and candid shots of people generally look best when the light is neutral, or white.

110 Setting ISO-E in good light

For general photographic applications in good light, an ISO-E setting of up to 200 will give good-quality images with little or no noise present.

107 Setting WB when using optical filters

Because the WB sensor measures the temperature of light entering the lens, adding any optical color correction filters will affect the WB reading and, in auto-WB mode, the camera will make adjustments to nullify the effects of the filters. In this instance, you will need to set WB manually.

108 Setting ISO equivalency (ISO-E)

ISO-E functions the same in digital as in film photography—the higher the rating, the faster the sensor reacts to light. However, unlike film, you can adjust the ISO-E rating for every single shot.

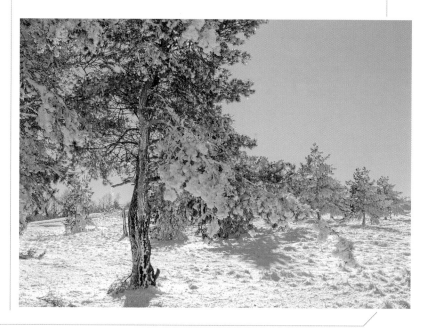

111 Setting ISO-E in low light

In fading light, consider shifting the ISO-E up to 400 (shifting ISO-E from 200 to 400 will give you one extra stop of light to work with). Beware, however, of the possible increase in noise, particularly in shadow areas.

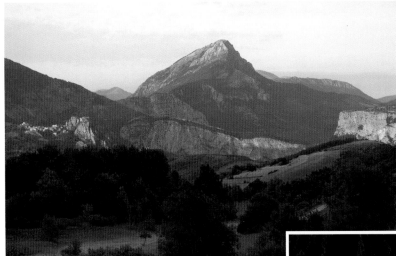

113 Acceptable noise

Having tested several digital SLRs, I have found noise to be acceptable up to a maximum of ISO-E 400 on most models. Much beyond 400 and noise becomes more apparent, adversely affecting image quality noticeably.

114 Minimizing digital noise

To minimize noise in-camera, try turning on the Noise Reduction function, found in the menu options. Noise can also be minimized in post-camera processing using specialist software applications, such as Dfine by Nik Multimedia.

112 Setting ISO-E for night-time photography

When photographing at night, set one of the faster ISO-E settings (ISO-E 800 and above). However, you will need to be aware that noise will almost certainly become a factor in image quality.

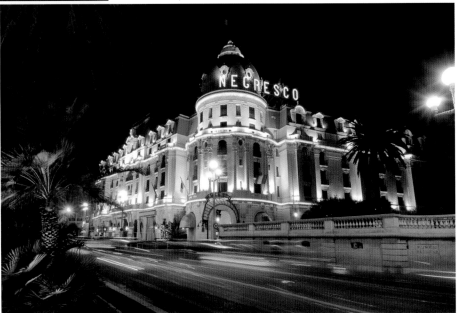

115 Noise Reduction

All DSLRs have a noise-reduction function available in the menu options. Some cameras have two noise-reduction settings—one for long-time exposures, and one for high ISO-E ratings.

117 High ISO-E noise reduction

Digital noise is also generated when the signal picked up by the sensor is amplified to increase sensitivity. High ISO-E Noise Reduction deals specifically with this type of digital noise.

118 Remember!

Remember to turn off the Noise Reduction function when it's unnecessary, as the time taken for the camera to run the process will slow the burst-rate.

116 Long-time exposure noise reduction

During long-time exposures, digital noise is created by the heat generated by the sensor. Long time Noise Reduction, when applied, deals specifically with this type of digital noise, but not the noise created by high ISO-E ratings.

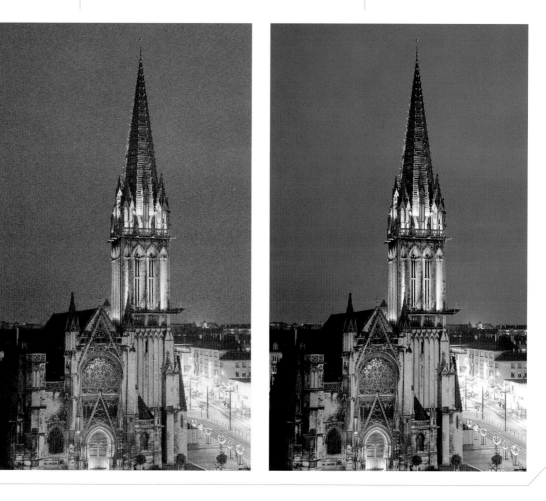

Using your DSLR

Shooting on the move

Gaining good camera skills and photographic technique are essential to making sure that you get the most from your DSLR and return from a photo session with images to be proud of. Those who don't know any better maintain that digital photography is in some way easy and tantamount to cheating. In reality, digital photography is not so different from film, and all the rules and guidelines that apply to film also apply to digital.

Camera-handling

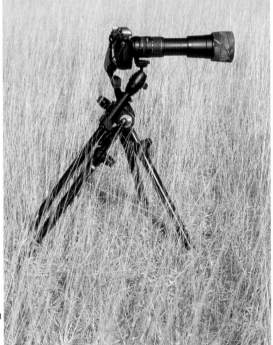

119 Use a tripod

Whenever possible, use a tripod to keep the camera steady and to avoid the adverse effects of camera shake on image quality. This is especially important when using relatively slow shutter speeds, such as 1/60 and below.

120 Where to attach the tripod

If you're using a physically short lens, then attach the tripod to the camera. However, if you're using a long telephoto lens, then, to gain better balance, attach the tripod to the lens, which should have a tripod collar.

121 Keep the center of gravity low

Extend the tripod only to the necessary height. The lower the center of gravity, the more stable the setup. Always spread the tripod legs as wide as they will go for added rigidity.

122 Use a cable release

When using a tripod to support the camera, always use a cable release to fire the shutter. This avoids vibrating the camera, which will cause image blur. If you haven't got a cable release with you, then use the self-timer option.

123 Beanbags

If you're photographing from a fixed position, then a beanbag makes an ideal and effective support. Used properly, beanbags can be better than tripods at keeping your images free of the blur caused by camera shake.

124 Hand-holding the camera

If you must hand-hold the camera, do so with your arms held close to your body and your feet slightly spread. If there is a suitable support, such as a wall or tree, use it to help support your weight. Breathe out when pressing the shutter.

125 Secure the strap

Wrap the camera strap around your wrist so that, should you drop the camera, it won't fall to the ground. This is particularly important when photographing on or around water, or in high places.

126 Add a vertical handgrip

Although vertical grips can be bulky and expensive, if your camera has the option to fit one, then do. As well as adding additional battery power, they make the camera better balanced and easier to hold, particularly when holding the camera in the vertical format.

127 Image sequences

If your camera's burst-rate is good enough, why not use your DSLR to tell a story with a sequence of rapidly taken images?

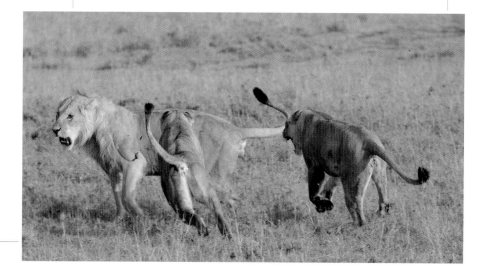

128 Burst-rate and file size

Image file size is one of the determining factors limiting the number of images that can be held in the buffer. Large file sizes, such as those produced when shooting in RAW or TIFF mode, take up more capacity than JPEG files, which have reduced file sizes due to compression.

129 Apply compression to increase burst-rate

To reduce the size of RAW files (or TIFF files), apply compression. In newer cameras this will improve burst-rate.

130 Remaining frames indicator

The frame counter in most DSLRs shows the remaining capacity, shown as the number of frames remaining, for both the memory card and the buffer. Keep an eye on this latter indicator when shooting an action sequence, as it will help you become more discerning when deciding when is the appropriate moment to fire the shutter.

131 Hone your instincts

Get to know how to operate the camera with your eyes closed—literally. The great photographers don't need to think about the controls—they control the camera instinctively, knowing exactly where each and every button is, which direction to rotate the dial, and which position to flick a switch.

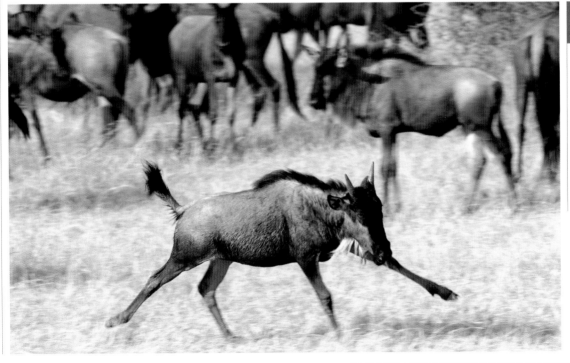

Selecting and using lenses

There are countless different lenses available from several manufacturers, varying both in physical size and focal length. Wide-angle lenses accentuate space, while telephoto lenses do the opposite, making subjects appear much closer to the camera. For close-up photography there are macro optics, and tilt-and-shift lenses for photographing architecture and buildings. There are also a growing number of digital-specific lenses, designed to work only with digital cameras.

132 Focal length

The focal length of the lens is the distance between its optical center and focal point, which is indicated in millimeters (mm) and is related to the magnifying power of the lens.

134 Wide-angle lenses

Wide-angle lenses have a focal length less than 36mm. As well as increasing the angle of view to include more of the scene, their effect is to expand the space between objects, making them appear further apart.

133 Standard lenses

In 35mm film photography, a 50mm lens is referred to as a "standard" lens because it approximates to our field of vision. As many digital sensors are smaller than the 35mm film frame, an equivalent "standard" focal length will vary between camera models.

135 Telephoto lenses

Telephoto lenses have a focal length greater than 60mm. As well as decreasing the angle of view to exclude areas of the scene, their effect is to compress the space between objects, making them appear closer together.

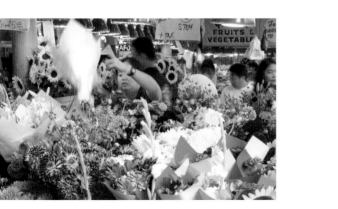

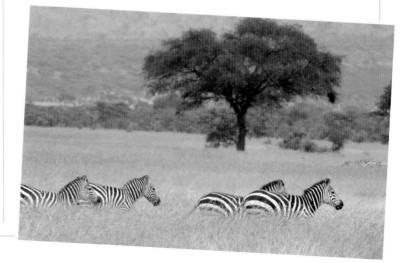

136 Macro lenses

Macro lenses are designed for close-up photography, and have an ability to close-focus on subjects and render them life-size or bigger. Typically, macro lenses can be used for non-macro photography, but the opposite doesn't apply.

137 Zoom lenses

Zoom lenses have a range of focal lengths within a single lens. The focal length range depends on the lens and can be narrow (e.g. 17-35mm) or very wide (e.g. 28-300mm). In general, the wider the range, the more optical quality is compromised.

138 Specialist lenses

There are a number of specialist lenses available that are used for different and specific purposes. For example, a tilt-and-shift lens can be used in architectural photography to minimize or eliminate converging verticals, caused by tilting the camera. A fish-eye lens is an extreme wide-angle lens, often having an angle of view close to 180 degrees.

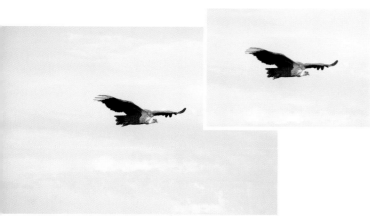

142 Why invest in a fast lens?

Although generally bigger, bulkier, and more expensive than slower lenses, fast lenses have the advantage of greater choice in selecting exposure settings. Most professional lenses will have fast apertures (f/4 or larger for super-telephoto lenses, and f/2.8 or larger for lenses below 300mm), while those aimed at the enthusiast market tend toward f/5.6 or even f/6.3 as their fastest aperture.

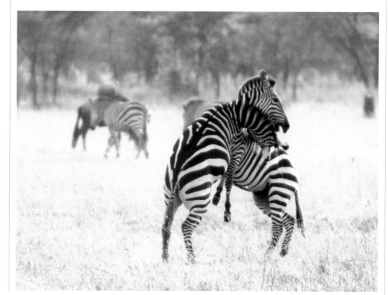

139 Focal length and magnification

Lens focal length determines image magnification. For example, in terms of human vision, a 50mm lens has an image magnification factor of 1. That is, it "sees" roughly the same as we see. A 100mm lens doubles the size of the subject, giving it a magnification factor of two (2x). A 200mm lens quadruples subject size (a magnification factor of 4x), and so on. In the opposite direction, a 24mm wide-angle lens will roughly halve the size of the subject in the frame (a magnification factor of .5x), and a 12mm lens will reproduce the subject at a quarter of the size of a 50mm lens (a magnification factor of .25x).

140 Focal length and perspective

Lens focal length also influences perspective and spatial relationships. By moving closer to your subject with a wide-angle lens, you can maintain subject size in relation to the image space, but completely alter the relationship between the subject and its environment.

141 Lens speed

Lens speed is determined by the maximum aperture, and refers to a lens's ability to gather light. The larger the maximum aperture, the more light it can gather and the faster the lens is said to be.

143 What is focal length magnification factor?

When people talk about focal length in terms of digital photography, they often refer to the focal length magnification factor (FLMF), or focal length multiplier. In a nutshell, any DSLR that isn't "full-frame" (i.e. has a sensor the same size as a 35mm film frame), will alter the picture angle of the lens, which gives the appearance of magnifying focal length. For example, a Nikon DSLR has an FLMF of 1.5x because its sensor is smaller than a 35mm film frame. Therefore, a 28mm lens has an apparent focal length of 42mm.

144 The reality about FLMF

It's important to avoid confusing focal length with picture angle. Irrespective of the dimensions of the sensor, the actual size of the subject is exactly the same with any single given focal length. For example, if you photographed a child playing, using a 35mm film camera and a 50mm lens, and the image of the child was reproduced on the film at 18mm in height, the image of the child would be reproduced at exactly the same size if photographed using a small-frame digital camera with a 50mm lens, although the reduced field of view would crop some of the visible space around the child, making him appear closer to the camera. This distinction is important when it comes to enlarging the image as both examples would require exactly the same amount of enlargement to reproduce a print of the child where he was, say, 180mm in height.

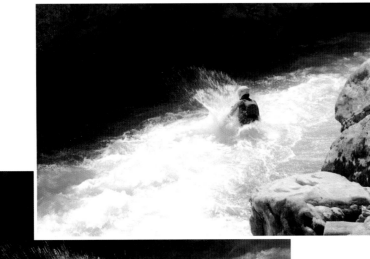

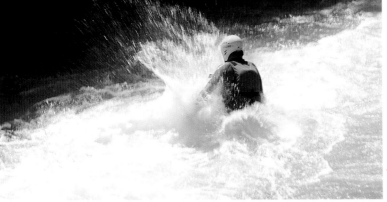

FLMF for different cameras

145 Nikon

All Nikon digital cameras have an FLMF of 1.5 times.

146 Canon

Canon cameras vary in the effects of FLMF. The EOS 1DS, 1DS Mark II, and EOS 5D do not have an FLMF, as they have full-frame sensors. The EOS 1D Mark II has an FLMF of around 1.3 times. The EOS 10D, EOS 20D, and EOS 350D (Rebel) cameras have an FLMF of approximately 1.6 times.

147 Olympus

Olympus digital SLR cameras have an FLMF of two times.

148 Konica Minolta

Konica Minolta digital SLR cameras have an FLMF of 1.5 times.

149 Pentax

Pentax DSLR cameras have an FLMF of 1.5 times.

150 FLMF conversion table

The following table shows the effects on focal length of the different focal length magnification factors.

Focal length magnification for different sensor sizes

Focal length with 35mm film camera (and full-frame DSLR)	Equivalent focal length field of view with 1.3x FLMF	Equivalent focal length field of view with 1.5x FLMF	Equivalent focal length field of view with 1.6x FLMF	Equivalent focal length field of view with 2x FLMF
17mm	22mm	26mm	27mm	34mm
20mm	26mm	30mm	32mm	40mm
24mm	31mm	36mm	38mm	48mm
28mm	36mm	42mm	45mm	56mm
35mm	46mm	52 mm	56mm	70mm
50mm	65mm	75mm	80mm	100mm
60mm	78mm	90mm	96mm	120mm
80mm	104mm	120mm	128mm	160mm
100mm	130mm	150mm	160mm	200mm
135mm	176mm	200mm	216mm	270mm
200mm	260mm	300mm	320mm	400mm
280mm	364mm	420mm	448mm	560mm
300mm	390mm	450mm	480mm	600mm

151 Digital-specific lenses

Some manufacturers–notably Nikon, Olympus, Tamron, and, more recently, Canon–are now manufacturing lenses specifically for digital cameras. So, what's the difference between a digital lens and a non-digital lens? The answer lies in telecentric lens design. Because of its physical depth, for each photodiode on the sensor to receive the maximum possible charge, light has to fall on it from as close to 90° as possible. Otherwise, if the angle is too great, then much of the information for that area of the scene is lost, causing vignetting, discoloration, and noise (most often seen at the edges of the frame). A telecentric lens design maximizes the quantity of light that hits the sensor at very close to a right angle, which optimizes image quality.

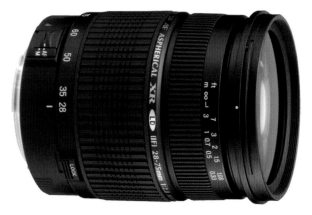

Top 10 tips for choosing lenses

152 Quality

Always buy the best lenses you can afford. It's better to have a less expensive camera body and a quality lens than vice versa.

153 Zooms

Zoom lenses provide the greatest flexibility in composition, allowing you to alter the focal length exactly as needed. When choosing a zoom lens, try to avoid extreme zooms (e.g. those that have a very wide range, such as 70-500mm or 28-300mm), as the quality of the optics is compromised by their versatility.

154 Primes

While being less versatile than zoom lenses, prime lenses (lenses of a fixed focal length) are generally of better optical quality. With extreme focal lengths, such as very wide-angle lenses and super-telephoto lenses, image quality will be noticeably better when using prime lenses.

155 AF lenses

Not all auto-focus (AF) lenses are as good as each other. If focusing speed is important to your photography, it's worth testing AF performance before you buy the lens.

156 Inside job

Internal focusing enables lenses to be more compact and lightweight in construction than lenses where the barrel extends outward when focusing.

157 Aperture

The maximum aperture of the lens will, to some extent, dictate the level of control you have overexposure settings. For example, in low-light conditions with a "slow" lens (a lens with a maximum aperture of f/5.6 or less), you may not be able to attain the shutter speed necessary to freeze motion or capture a sharp image.

158 Zoom issues

With some zoom lenses the maximum aperture can vary depending on the focal length set. This system is used to reduce the size and weight of the lens but, again, can limit your options when it comes to setting exposure. If possible, always opt for a zoom lens with a fixed maximum aperture.

159 Glass

Lenses that use low dispersion glass help to minimize chromatic aberration, a type of image and color dispersion that occurs when light rays of varying length pass through optical glass. In so doing, they improve sharpness and color correction.

160 ALEs

Lenses with Aspherical Lens Elements produce better image quality by eliminating the problem of coma (distortion at the edge of the image) and other types of aberration, particularly prevalent in wide-angle lenses used in conjunction with large apertures.

161 Stability

Increasingly, lenses are being produced with some form of optical stabilization. These lenses make hand-holding the camera at slow shutter speeds more practical, and reduce the likelihood of image blur caused by camera shake. They are widely used in sports and wildlife photography.

162 Changing lenses and dust on the sensor

Dust on the sensor is a major problem for digital photographers. Every time a lens is changed the sensor is exposed, increasing the likelihood of dust and dirt particles attaching themselves. Using zoom lenses reduces the need to change lenses so often. When changing lenses, always do so in a clean environment, if possible, and turn off the camera.

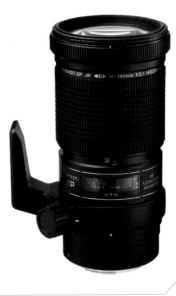

Focusing

For images to appear sharp, the subject has to be in focus. Digital SLRs have sophisticated autofocus systems to help achieve this, but to get the best from them it's necessary to understand how they work and what their limitations are. This section demystifies the art of AF.

163 Activating AF mode

AF can be activated using either the shutter or the AF-ON button (if your camera has one). In nearly all cases it is simplest to activate AF via the shutter release.

Selecting the appropriate focus mode

164 Standard (single) AF

For still life or stationary subjects, use the standard, sometimes referred to as "single-servo" autofocus mode. In this setting the camera will focus on the subject and lock the focus point until the picture is taken. Typically, priority is given to focus, and the shutter locked by the camera unless the camera has achieved focus, preventing out-of-focus pictures.

165 Continuous AF mode

If the subject is moving, single-servo AF is inappropriate, as the subject is likely to move beyond the point of focus before the image is taken. In this instance, continuous AF mode is the better option. In this setting the camera first detects the point of focus but continues to monitor the position of the subject, constantly adjusting focus distance to match.

166 Using AF-Lock

It's possible to lock focus in both single-servo and continuous AF mode by pressing the AF-Lock button (if your camera has one).

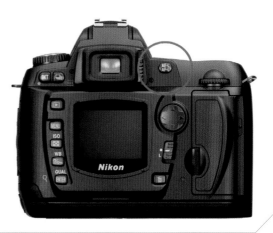

167 Focus/shutter priority

In continuous AF mode, the camera typically gives priority to the shutter, meaning that the shutter can be activated even if the subject isn't in focus. Some cameras have a menu option that enables the user to switch to focus priority, which is a better option. After all, there's little point in taking an out-of-focus picture.

168 When to use the manual setting

Remember that your DSLR also has a manual focus mode and that, while AF is often an ideal solution for many subjects, for some it can make the job of focusing on the right subject a harder one.

169 Switch back

If you have selected manual focus for a specific shot, remember to switch back to AF before using your camera again.

170 Selecting an appropriate AF area sensor

DSLRs have a number of AF area sensors, these being the active points in the viewfinder that detect focus distance. The exact number of sensors varies between cameras, but is usually 5-11.

171 Selecting the right sensor

AF sensors are useful when focusing on off-center subjects. Simply select the sensor that covers your subject, and the camera will do the rest.

172 Focus tracking

Multiple AF sensors also enable focus-tracking, which is when the camera tracks the movement of a subject as it travels across the frame—for example, a bird in flight. For focus tracking to operate, it is necessary to ensure that all the AF sensors are enabled. Check your camera manual to see how to do this.

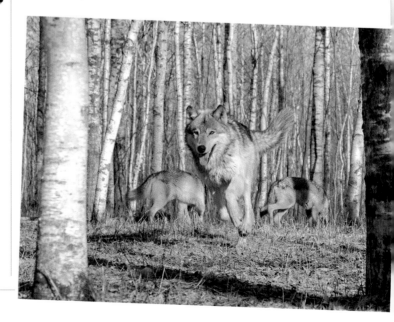

173 Closest subject

Some DSLRs have an area sensor mode called Closest Subject. In this instance, the camera automatically selects the AF area sensor covering the subject closest to the camera. This is meant to speed and ease the process of focusing. However, it assumes that the subject closest to the camera is the main subject, so use this setting cautiously.

174 Locking the AF area sensor selector

With some cameras it is easy to unintentionally knock the AF area selector and inadvertently switch between sensors. To avoid this happening, once the appropriate sensor is selected, lock it in place.

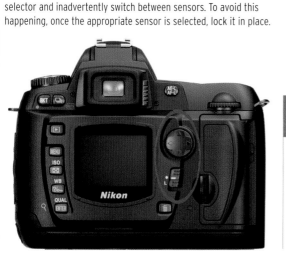

175 Focusing in low light

Some DSLR cameras have an AF-assist illuminator that helps the camera to autofocus in the dark. When photographing in low-light conditions, try to ensure that this lamp isn't obstructed. otherwise, you may find that AF doesn't work properly.

176 Focusing on stationary or still-life subjects

If your subject is stationary and unobstructed, then frame it in the viewfinder, select the appropriate AF area sensor, and use the single-servo AF mode. So long as the subject remains stationary, the camera will set an accurate focus distance and you can take the picture.

177 Focusing on moving subjects

If your subject is moving in a predictable manner— for example, a racing car on a racetrack—then set the AF mode to continuous, and ensure that all the focus points are active. Frame the subject in the viewfinder and select the appropriate AF area sensor. With the camera in continuous AF mode, it will automatically track the subject as it moves within the frame.

178 Focusing on an obstructed subject

If the subject is obstructed by something—for example, if the subject is a bird hidden in reeds—then you may find that manual focus is the most accurate and quickest method of focusing. In AF mode, in these circumstances, the camera is likely to be unable to isolate the subject and will go into what is known as AF-hunt mode, where it continually attempts to focus without ever detecting focus. Alternatively, it may focus on the wrong subject altogether.

179 Focusing on off-center subjects

With multiple AF area sensors, the problem of focusing on off-center subjects is less a problem than it used to be. However, there will always be occasions when the subject falls outside of any of the multiple sensors. If this happens, select a sensor and focus on the subject. Once focus is attained, lock it using the AF-Lock button or the shutter-release button, then reframe the image through the viewfinder for your preferred composition. Keeping focus locked, take the picture.

180 Depth of field

There is only one point of focus, but because of the limitations of human eyesight, other areas of the scene may appear sharp. This is known as depth of field. Three things influence the extent of depth of field—the lens aperture, camera-to-subject distance, and focal length.

181 Depth of field increases when...

Small lens apertures are set (e.g. f/11, f/16); the subject is distant from the camera; wide-angle lenses are used.

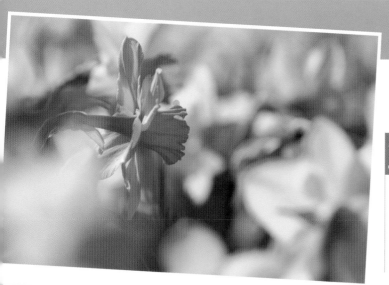

185 Overcoming shallow depth of field

You can balance depth of field by negating one factor from another. For example, if you are using a long telephoto lens, set a small lens aperture to compensate. The same would apply in macro photography, where the subject is close to the camera. If you have to use a large lens aperture, try using a short focal length lens.

182 Depth of field reduces when any of the following apply...

Large lens apertures are set (e.g. f/2, f/2.8, f/4);
the subject is very close to the camera (e.g. in macro photography);
long telephoto lenses are used.

186 Reducing depth of field

Sometimes, very narrow depth of field is the aim. For example, a lack of detail in the background caused by poor depth of field can help to isolate the subject, making it stand out.

183 Use the depth-of-field preview button

To assess the extent of depth of field, you can use the depth-of-field preview button (if your camera has one). When pressed, this button causes the camera to stop down the lens to the working (set) aperture, and will reveal those subjects within the frame that appear sharp and those that don't.

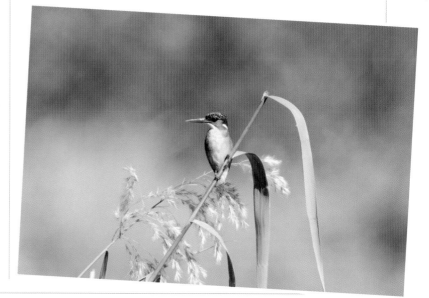

184 Practice using DOF preview

With the lens stopped down to any aperture smaller than the maximum aperture, the viewfinder will darken, as less light enters the lens. It takes a while to get used to this phenomenon, and it is worth practicing the technique before relying on it in the field.

187 Subjects that typically require significant depth of field

Landscapes;
cityscapes;
reportage.

188 Subjects that can benefit from a narrow depth of field

Formal portraits;
wildlife;
sports.

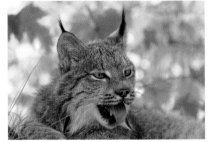

189 Hyperfocal distance and hyperfocal focusing

Hyperfocal distance refers to the point of focus at which the greatest depth of field is attained in any given set of circumstances. To maximize depth of field, set the lens to focus on infinity and then use the depth-of-field preview button to assess the point closest to the camera that appears sharp. Refocus on this point and take the picture.

190 Warning!

Never try manually focusing the lens when the camera/lens are set to AF, as it may damage the AF motors.

191 Exposure

Making sure your images are accurately exposed—not too light and not too dark—is fundamental to good photography. The automatic meters built into DSLR cameras are highly accurate, to a point. However, they have limitations, and mastering the camera's metering system is one of the most important things you'll do. It's also one of the key elements to improving the consistency of your photography.

192 Through-the-lens (TTL) metering

The meter in your DSLR is known as a through-the-lens (TTL) reflected light meter. It measures the light reflecting off the subject and entering the lens. In many ways, it is the most accurate form of metering for photography.

Exposure modes

All DSLR cameras have a number of different exposure modes, the exact options being dependent on the type of camera and its intended market. Professional-specification cameras, such as the Nikon D2X and D2Hs, and the Canon 1DS mark II, have four main options. Cameras aimed more at the hobbyist tend to have additional programmed settings to make automatic exposure of diverse subjects easier.

196 Child mode

Not available on all models of camera as a separate setting, Child mode is programmed for use when photographing active children—for example, at a party or playing in the park. In essence, the camera uses a similar process to Sports mode for exposure decisions.

193 The programmed settings

In full program mode the camera sets both the shutter speed and the lens aperture—the user simply has to point the camera and shoot. While this may limit creativity and be over-reliant on the camera making the decisions, it is an excellent way of enabling someone new to photography to learn other aspects of the camera without overcomplicating the process at the beginning.

194 Sports mode

The Sports mode is programmed for use with sporting subjects, such as athletics events, football games, and motor racing. Typically, the camera will give priority to shutter speed, setting a fast shutter speed to freeze action.

195 Also use Sports mode for:

Photographing animals that are moving; children playing; any fast-moving subject, such as cars, motorbikes, skiers, and so on.

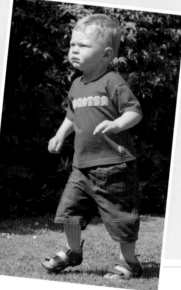

197 Portrait mode

Portrait mode is programmed for use with formal portraits of people. In this mode the camera gives priority to lens apertures and will set an aperture to minimize depth of field, helping to isolate the subject from the background.

198 Also use Portrait mode for:

Formal portraits of animals;
still-life photography;
flowers (in non-close-up situations).

199 Night Portrait

Night Portrait mode is programmed for use when photographing people in low light, such as at a party. The camera is careful to set a shutter speed that will minimize the likelihood of camera shake.

200 Landscape mode

Landscape mode is programmed for use when photographing landscape scenes. Priority is given to lens aperture, and the camera will set as small an aperture as possible to maximize depth of field.

201 Also use Landscape mode for:

Seascapes;
daytime cityscapes;
street scenes.

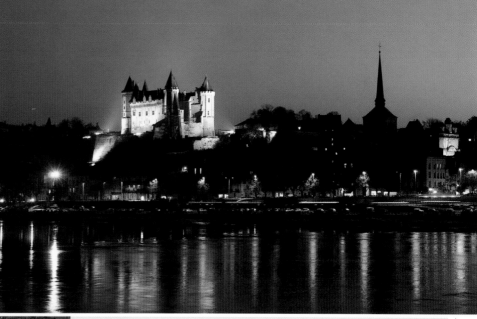

202 Night Landscape mode

Night Landscape mode is programmed for use when photographing landscape scenes in low light, such as a city scene or a landscape at dusk. The camera sets a shutter speed that will minimize the likelihood of camera shake, while maintaining good depth of field.

203 Also use Night Landscape mode for:

Photographing cities at night;
sunrise;
sunset.

204 Close-up mode

Close-up mode is programmed for the photography of plants, flowers, and small creatures. The camera will balance the need for an adequately fast shutter speed with extended depth of field.

205 Auto program mode

The purpose of the scene indicators in program mode is to tell the camera something about the subject you are photographing. This helps the camera decide the best combination of lens aperture and shutter speed for the situation. In Auto program mode the camera will simply set an aperture and shutter speed that will give reasonable results in most circumstances.

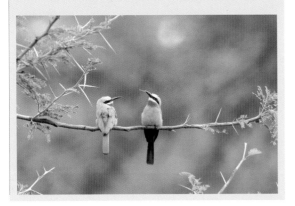

Manual and semi-manual metering modes

All DSLR cameras will have a manual and two semi-manual exposure modes available, which give the user much greater control overexposure decisions, while still enabling the camera to assist in the exposure process.

206 Aperture-priority AE mode

In Aperture-priority AE mode, the user sets the lens aperture while the camera sets an appropriate shutter speed.

207 Aperture range

The aperture refers to the size of the hole in the diaphragm of the lens and is indicated by an f/stop number. Large f/stop numbers indicate a small aperture, and small f/stop numbers indicate a large aperture.

208 Know your f/stops

The larger the aperture you set, the less depth of field you will have to work with, the smaller the aperture, the greater the available depth of field.

209 Getting to grips with aperture size

It can be a little confusing—the bigger the number, the smaller the aperture. The best way to think of f/stop numbers is to think in fractions. For example, 1/8 is bigger than 1/16, just as f/8 is a bigger aperture than f/16.

210 Use Aperture-priority AE mode for

Use Aperture-priority AE mode when managing depth of field is important, such as in landscape photography, where it's important to have foreground and background detail sharp.

211 Shutter-priority AE mode

In Shutter-priority AE mode, the user sets the shutter speed and the camera sets an appropriate lens aperture.

212 Shutter speed ranges

The range of shutter speeds varies between cameras, and is typically between eight sec and 1/4000 sec. Some cameras will have a wider range, from about 30 sec up to 1/16,000 sec. In practice, for most general-purpose situations, shutter speeds ranging between 1/60 sec and 1/500 sec are used. Some of the other shutter speeds become appropriate during more advanced photography techniques.

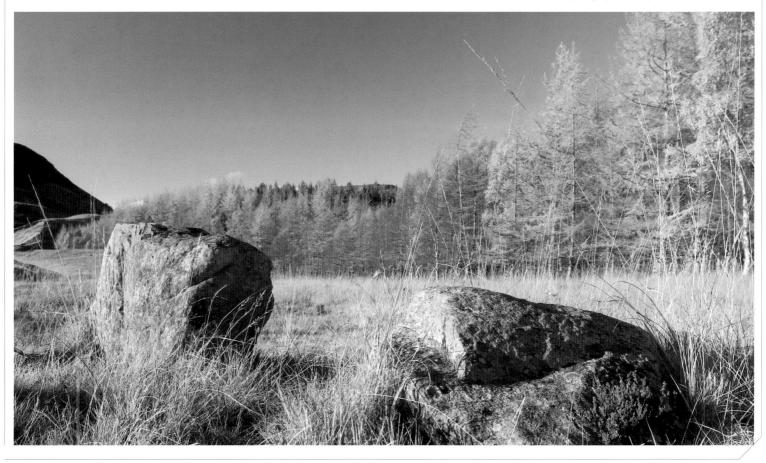

213 Bulb (Time) setting

For exposure longer than the camera's minimum preset shutter speed, there is a setting referred to as the Bulb setting (sometimes known as the Time setting). When set to Bulb, the shutter will remain open as long as the shutter-release button is pressed down (either manually or via a cable). This allows for shutter speeds of several minutes and even hours.

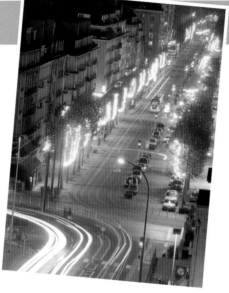

214 Use Shutter-priority AE for:

Use Shutter-priority AE when you want to control how motion appears in the photograph. A fast shutter speed will freeze motion, while a slow shutter speed will blur it.

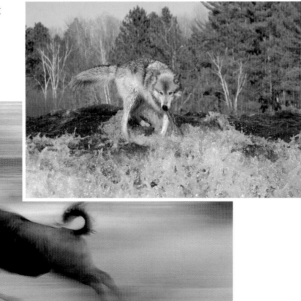

215 Manual mode

In Manual mode, everything is left to the photographer, giving him or her the ultimate level of control of exposure decisions. Manual metering can be done in conjunction with the camera's TTL (through-the-lens) meter, which is used to assess the level of available light.

216 Use manual metering mode when:

Use manual metering mode when you want to have the greatest level of control overexposure for highly accurate exposures or for artistically interpreting a scene.

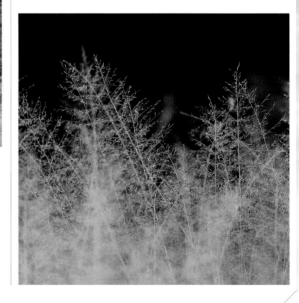

217 Adjusting exposure settings

Exposure settings can be adjusted in degrees, depending on the camera model. All exposures can be adjusted in full f/stops. For example, changing the shutter speed from 1/30 sec to 1/60 sec is a full 1-stop increase in shutter speed; altering the aperture from f/11 to f/8 is a full 1-stop increase in aperture.

218 1/2- and 1/3-stop increments

Most cameras also enable changes to exposure settings to be made in 1/2- or 1/3-stop increments. For example, changing the shutter speed from 1/60 sec to 1/45 sec is a 1/2-stop decrease in shutter speed; changing the lens aperture from f/11 to f/13 is a 1/2-stop decrease in aperture. These fine adjustments of exposure enable critical exposure control.

219 Metering modes

As well as providing different exposure modes, DSLR cameras have different ways of metering a scene, which are determined by the set metering mode.

220 Multi-segment metering

Multi-segment metering is known by different names depending on the manufacturer. Nikon calls it Matrix metering, Canon call it Evaluative metering, Minolta call it Honeycomb. In essence, they all work the same way. The camera assesses the level of light in different areas of the frame and then averages the results to provide appropriate exposure information. With some cameras this is done in conjunction with a database of historic image data held in a small computer in the camera. This is the most accurate form of AE metering in the majority of circumstances and works well in most situations.

221 Use multi-segment metering for:

General-purpose photography; difficult lighting conditions.

222 Center-weighted metering

This is the original form of AE metering and works on the basis that the subject fills a large area of the central portion of the frame. Metering decisions are weighted toward a ratio of 75% center/25% background. Despite its lack of sophistication, it is remarkably accurate, particularly when photographing portraits and, in some cases, backlit subjects.

223 Changing the size of the center circle

Some DSLR cameras enable you to adjust the diameter of the center circle used to determine the central portion of the scene. For example, the Nikon D200 has a choice of 6mm, 8mm, 10mm, and 13mm. This can be useful for attaining more accurate exposures in center-weighted metering mode.

224 Use center-weighted metering mode for:

Formal portraits of people and animals; backlit subjects (except silhouettes).

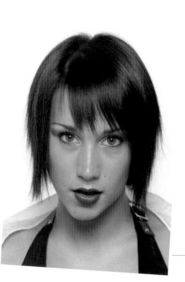

225 Spot metering mode

In Spot metering mode, the camera measures light levels from a very small portion of the frame, typically an area no more than 2-3% of the overall scene. This makes it ideal for creative exposure and for accurately assessing exposure for high-contrast scenes, or scenes of multiple tones.

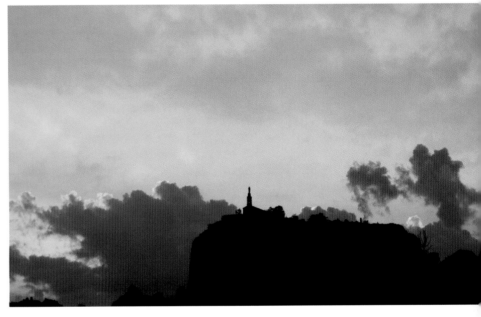

226 Use spot metering mode for:

Landscape photography;
critical exposures;
assessing the subject brightness range (SBR).

227 Using manual metering mode

Manual metering is best done in conjunction with the camera's analog meter display in the viewfinder. As you adjust either the lens aperture or the shutter speed, you will notice the bar display change in relation to the fixed scale. What you are aiming for is the moving bar in the display to align with the "0" marked on the scale, indicating that the exposure settings are in line with the meter reading.

228 Indicating underexposure

If the analog exposure scale indicates underexposure, increase the aperture or reduce the shutter speed to allow more light to enter the camera.

229 Indicating overexposure

If the analog exposure scale indicates overexposure, reduce the aperture or increase the shutter speed to allow less light to enter the camera.

230 The sunny f/16 rule

When taking pictures in bright sunlight, the high level of contrast can sometimes confuse a camera's internal meter. To avoid inaccurate exposures in these conditions, set the lens aperture to f/16 and the shutter speed equivalent to the ISO-E rating. This is known as the "sunny f/16 rule," and is remarkably accurate.

231 The sunny f/22 rule

When photographing predominantly white or very light subjects in bright sunlight, a variation of the sunny f/16 rule is the sunny f/22 rule. The process for assessing exposure is the same, except that f/22 is used as the base aperture. By stopping down by one stop, you avoid overexposing the highlights.

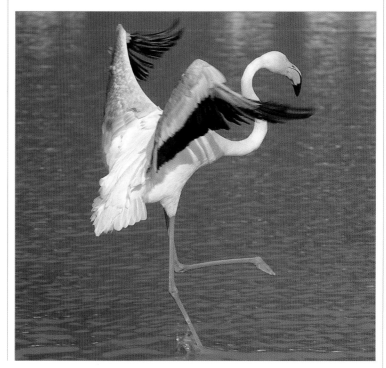

232 Law of reciprocity

When using the sunny f/16 rule, you can set any equivalent combination of exposures once you have your base exposure by applying the law of reciprocity. This law dictates that any change in aperture can be compensated for by an equal and opposite change in the exposure time.

233 Equivalent exposure settings using the law of reciprocity

An exposure of f/16 @ 1/100 sec is equal to any of the following exposures:

f/32 @ 1/25 sec	f/5.6 @ 1/800 sec
f/22 @ 1/50 sec	f/4 @ 1/1600 sec
f/11 @ 1/200 sec	f/2.8 @ 1/3200 sec
f/8 @ 1/400 sec	f/2 @ 1/6400 sec

234 The EV chart

The EV chart is a useful tool to carry with you. It shows all the possible exposure combinations for any given exposure value.

235 Long-time exposures and digital noise

The heat generated by the sensor during exposures greater than 1/2 sec causes digital noise to form, visible as random, unrelated pixels. To minimize the occurrence of noise, avoid long-time exposures wherever possible.

236 Noise Reduction in Photoshop

Don't worry if you forget to switch on the noise reduction function for either high sensitivity or slow shutter speed as it's possible to perform noise reduction in image editing software such as Photoshop.

237 ISO-E rating

Unlike film-based photography, the ISO rating (the sensitivity of the sensor) can be adjusted for each individual shot. As we've explored already, digital cameras refer to the ISO rating in the same terms used for film. The higher the ISO-E rating, the more sensitive the sensor is to light. The lower the ISO-E rating, the less sensitive the sensor is, and the greater the level of light needed to form an image.

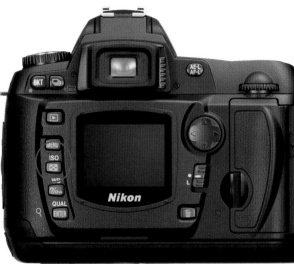

238 ISO-E rating ranges

Although varying between cameras, the typical range of ISO-E ratings is: 100, 125, 160, 200, 250, 320, 400, 500, 640, 800, 1000, 1250, and 1600. A few cameras have lower ratings (50) and higher ratings (up to 3200).

239 Low, medium, and high sensitivity

ISO-E ratings up to ISO 160 are considered low sensitivity. Between ISO-E 200 and ISO-E 400, sensitivity is considered medium. Above ISO-E 400, and the sensitivity is considered high.

240 Use low sensitivity ISO-E ratings when:

Slow shutter speeds are acceptable (e.g. stationary subjects and the camera is mounted on a tripod); very small lens apertures are needed in low-light conditions (e.g. landscape photography at dawn and dusk); maximum image quality is imperative.

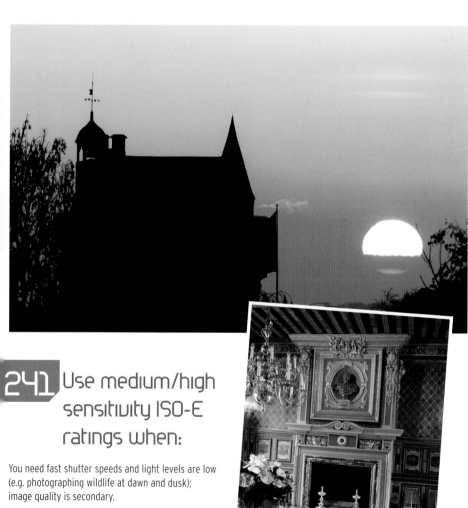

241 Use medium/high sensitivity ISO-E ratings when:

You need fast shutter speeds and light levels are low (e.g. photographing wildlife at dawn and dusk); image quality is secondary.

242 Quality and ISO-E

For maximum image quality, always use the lowest ISO-E rating available on your camera.

243 ISO-E and digital noise

As you increase the ISO-E rating, the camera amplifies the signal, resulting in an increase in digital noise. To lessen the likelihood of noise visible in the final image, keep ISO-E ratings below ISO-E 400.

244 ISO-E noise reduction

Some cameras have a separate control for handling digital noise caused by high ISO-E ratings, selectable via the menu options. Apply this function whenever ISO-E is set at 400 or above.

245 Beware!

Both long-time exposure and high ISO-E noise reduction functions will slow down the speed of processing, which will adversely affect burst-rate. The greater the presence of noise, the longer it takes the camera to process the image, and the slower burst-rate becomes.

246 Auto-ISO-E

Some DSLR cameras have an auto-ISO-E function that, when set to On, enables the camera to adjust the ISO-E rating automatically to attain optimal exposure within user-specified parameters. This function is useful for general purpose snapshot photography but should be avoided if image quality is an important factor in your image-making.

Tools for assessing exposure in-camera

247 The histogram

A very useful additional to the photographer's arsenal provided by digital cameras is the histogram. This is a graphic representation of the range and frequency of occurrence of tones in an image. It can be used to assess accurate exposures.

248 The histogram graph

The histogram is a bar chart showing the tonal value on the horizontal axis, ranging from black (value 0) to white (value 255), and the quantity of pixels having that value in the vertical axis.

249 The ideal histogram

There is no such thing as an "ideal" histogram, although for most situations there should be a fairly even spread of pixels between dark and light.

250 Histograms and underexposure

If a histogram shows a high percentage of the pixels showing dark tones, then this is an indication of an underexposed image. Increase lens aperture or reduce the shutter speed to increase the level of light reaching the sensor.

251 Histograms and overexposure

If a histogram shows a high percentage of pixels in the bright tones region, then this is an indication of an overexposed image. Decrease lens aperture or increase the shutter speed to reduce the level of light reaching the sensor.

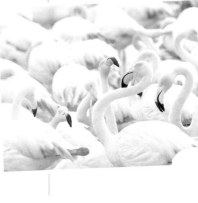
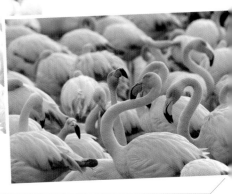

252 Histograms and contrast

For most scenes an image should have a full range of tones from black through medium gray to white—otherwise known as good contrast. If the readout shows low levels across the dark to light scale, then it is an indication that there is a lack of contrast and the picture may appear flat, two-dimensional, and lacking form. Increase the tone to increase the level of contrast.

253 Warning!

The histogram shown in-camera is based on JPEG data and will not always be consistent with a histogram depicting RAW or TIFF data. The in-camera histogram should be used only as a guide to exposure and tonal levels.

254 Learning to interpret histograms

Histograms are an indication of the accuracy of exposure, but must be looked at in context. For example, the histogram for a silhouette could be interpreted as an underexposed image. Indeed it is, but that is the intention. Similarly, a high-key image would be depicted by a histogram skewed heavily to the right, indicating overexposure. Again, in this instance, that is the intention.

255 Highlights screen

Another very useful feature of digital cameras is the highlights screen. The information shown here provides a visual identification of pixels that are beyond the dynamic range of the sensor at the highlight end and have no digital value. Avoiding highlights is critical in digital photography as a lack of any value means there is nothing to process, either in-camera or later in-computer.

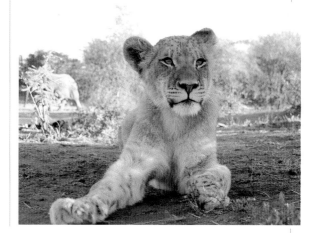

256 Highlight identifier

Highlights beyond the dynamic range of the sensor are indicated by a flashing black pixel, easily noticeable when the highlights information set is turned on.

257 Adjust exposure

Where a scene contains many burned-out highlights, it is suffering from overexposure in those areas identified. Adjust the exposure to reduce the amount of light entering the camera.

258 Exposure compensation

A simple method of adjusting exposure is to use the exposure compensation function on the camera. This control enables you to dial in a specific amount in stops by which to vary exposure from the camera's AE settings. For example, if you select +1-stop exposure compensation, every time a picture is taken the camera will increase exposure from the meter reading by 1-stop.

259 Remember!

Remember to reset exposure compensation to +0 once you've finished using it. Otherwise, all subsequent exposures will be adjusted, leading to inaccurate results.

260 Incremental adjustments

Exposure compensation can usually be applied in 1/3-, 1/2-, or one-stop increments.

261 Bracketing

Bracketing is the process of taking two or more near-identical photographs of the same scene at varying exposures above and/or below the camera's AE settings. DSLRs have an auto-bracket function that will perform this task automatically as specified by the user through the menu options or other camera controls. Use this technique when it is difficult to gauge with any certainty the ideal exposure.

262 Bracketing in aperture-priority AE mode

When the camera is set to aperture-priority AE mode, the camera will adjust the shutter speed when performing auto-bracketing.

263 Bracketing in shutter-priority AE mode

When the camera is set to shutter-priority AE mode, the camera will adjust lens aperture when performing auto-bracketing.

264 Bracketing in programmed AE mode

When the camera is set to program AE mode, the camera will adjust the shutter speed, lens aperture, or a combination of the two, when performing auto-bracketing.

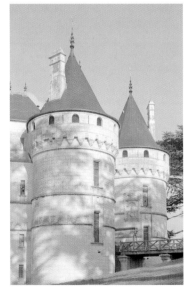
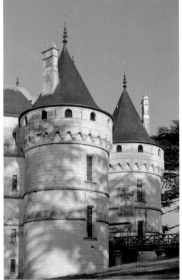

265 Bracketing and moving subjects

Bracketing is less effective with a moving subject, as each shot is likely to be very different from the previous and subsequent frames.

266 Manual bracketing

You can bracket an image sequence in manual mode by simply under- and overexposing by the desired amount, as indicated by the analog exposure scale in the viewfinder.

267 Setting auto-bracketing

Auto-bracketing can be specified by two parameters: the number of frames and the level of exposure compensation. The bracketing parameters found on most DSLR cameras enable sequences of up to 5-frames in 1/3-, 1/2-, or 1-stop increments. For example:

+0, +1-stop, -1-stop
+0, +2-stops, +1-stop, -1-stop, -2-stops

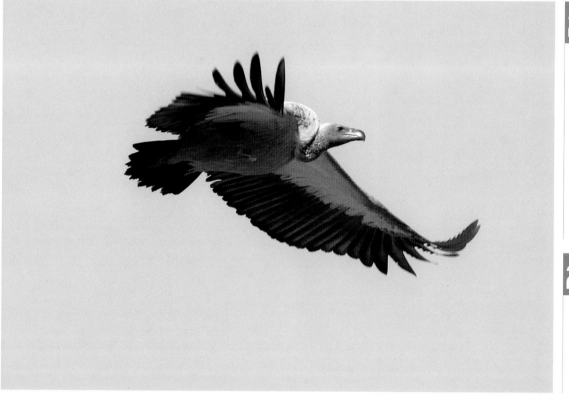

268 Smaller increments

Typically, setting auto-bracketing in increments of 1/3- or 1/2-stops will give better results than full 1-stop adjustments.

269 Remember!

Remember to switch off auto-bracketing once you have completed a sequence. Otherwise, you'll end up taking five times as many pictures as you need.

Flash Photography

Getting it right

Flash photography opens up a new world of photo opportunities and brings with it its own challenges, such as how to determine the correct exposure, whether to invest in an external flash unit, and how to make flash light appear natural. This section answers these questions and more.

270 Using the built-in flash

Most DSLR cameras have a built-in pop-up flash, although this is often missing from professional-specification digital cameras, such as the Nikon D2X and D2Hs. This small flash unit is useful for adding fill light to shadow areas, and can also be used to provide sufficient light when photographing in low-light conditions.

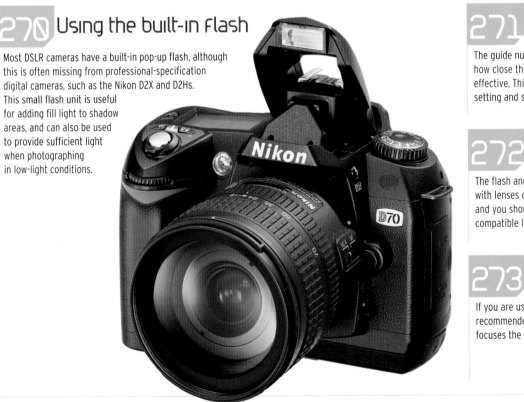

271 Guide number

The guide number (GN) of a flash unit determines its power and how close the subject must be to the camera for the flash to be effective. This distance will vary depending on the lens aperture setting and should be identified in the user manual.

272 Compatible lenses

The flash angle of the built-in flash means that it is only compatible with lenses of a certain focal length. This will vary between camera, and you should check your user manual. However, in general, compatible lenses range between 18mm and 300mm.

273 Use a flash extender

If you are using a lens with a focal length greater than the maximum recommended for the flash use a flash extender. This accessory focuses the beam from the flash light effectively extending its range.

274 Front-curtain sync

Front-curtain flash sync is recommended for most forms of general flash photography when the shutter speed is between 1/60 sec and 1/250 sec. In this mode, the flash fires the instant the shutter opens.

275 Rear-curtain sync

When photographing moving objects that are lit, in front-curtain sync mode a light trail will appear in front of the subject, which looks unnatural. In rear-curtain sync mode, the flash fires just before the shutter curtain closes, making any light trails appear behind the subject, with the effect that the subject appears to be moving forward.

276 Slow-sync mode

In dim lighting and at night, standard flash will illuminate the subject but be insufficient to light the background, which is underexposed and rendered dark or black in the photograph. Slow-sync mode enables flash to be used with slow shutter speeds, allowing more of the ambient light to reach the sensor, lightening dark backgrounds.

277 Red-eye reduction

When set to red-eye reduction mode, the flash emits a series of pre-flashes aimed at reducing the size of the subject's pupils, lessening the likely occurrence of red eye. This setting can be used when photographing people and animals.

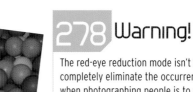

278 Warning!

The red-eye reduction mode isn't foolproof, and is unlikely to completely eliminate the occurrence of red-eye. A better solution when photographing people is to diffuse the flash light or, better still, use an external flash unit.

279 Metering mode

Automatic flash metering is served best when the metering mode is set to multi-segment metering or to center-weighted metering.

280 Flash-ready light

Always check that the flash-ready indicator is lit before taking a picture. If taking a sequence of images, you may need to wait momentarily between exposures for the flash unit to recharge.

281 Diffusing the built-in flash

To diffuse the light emitted from the built-in flash, cover it with an opaque, thin, white material, such as a cotton handkerchief.

282 Camera-to-subject distance

Make sure that the subject is within range of the flash. For detailed camera-to-subject distance ranges, consult your user manual. Alternatively, review the photograph on the LCD monitor and use the histogram to confirm an accurate exposure.

283 Flash-sync speed

The flash-sync speed refers to the maximum shutter speed that can be used with a flash unit, either built-in or external. It varies between cameras but is typically about 1/125 sec or 1/250 sec. For some high-level cameras, it can exceed 1/1000 sec.

284 Auto flash exposure compensation

The camera can be told to vary the power of flash output using flash exposure compensation, in much the same manner that non-flash exposure can be increased or decreased using exposure compensation. Increasing flash output will make the subject appear brighter; reducing flash output will darken the subject.

285 Main subject darker than the background

When the main subject is darker than the background, consider increasing flash output by setting positive (+) flash exposure compensation.

286 Main subject is lighter than the background

When the main subject is lighter than the background, consider decreasing flash output by setting negative (-) flash exposure compensation.

287 Incremental flash exposure compensation

Flash exposure compensation can be applied in increments, usually of either 1/3, ⁜, or 1-stop. The smaller the incremental change, the more accurate the exposure is likely to be.

288 Locking flash output

Some DSLR cameras enable flash output to be locked once an exposure has been determined, in the same way that non-flash exposure can be locked. Refer to your camera's user manual for details of how to lock flash exposure.

289 Connecting multiple flashes

It's possible to connect more than one flash unit using a flash bracket and the appropriate cables. In this instance, one flash will act as the trigger unit and the other the slave unit. When using multiple flash setups it's important for accurate exposures that they are "dedicated" to the camera make.

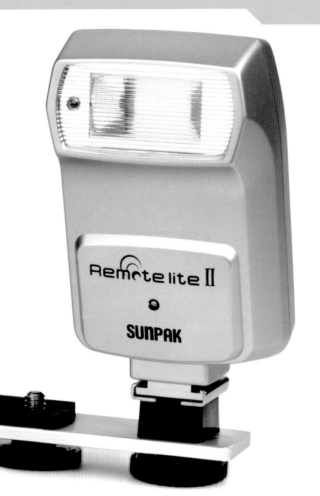

290 Why use an external flash?

Typically, external flash units are more powerful and have a greater range than built-in units. When mounted via a flash bracket, the angle of the flash relative to the subject overcomes the limitations of front-on flash.

291 Connecting an external flash

External flash units are mounted on the camera via the accessory shoe, or off-camera using a flash bracket. The flash is then linked to the camera via an electronic connecting cord. Both options provide a dedicated link between the flash and the camera that ensures an accurate discharge of illumination when the shutter is activated.

Types of external flash

292 Hammerhead flash

Hammerhead flashes are the most powerful, have the greatest range and quickest recycling times, and are designed to work off-camera. They consist of a large flash head mounted on a stem that doubles as a handle. Although they are less portable than the smaller external units, a wide choice of accessories greatly increases the possibilities for practical application in the field.

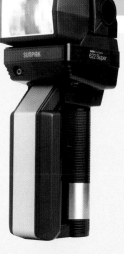

293 Ring flash

These flash types are specially designed to produce distinctive near-shadowless lighting. They are commonly used in closeup and macro photography, and attach to the front of the lens, with the front element poking through a hole in the middle of the flash unit.

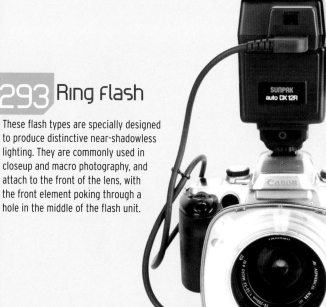

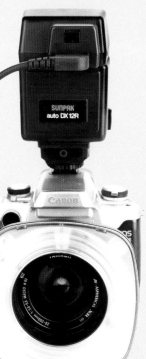

294 Slave flash

Typically smaller than the principal unit, slave flashes are generally used to provide fill-flash or to create specific lighting effects. They operate via a built-in sensor that detects when the main flash fires and then sets off the slave flash. They are useful accessories to carry, often filling the role of providing fill-flash when artificial light is the primary source of illumination.

295 Tilting-and-rotating heads

Tilting-and-rotating heads enable the light emitted by the flash unit to be reflected off a wall or other object, diffusing the light into a softer quality.

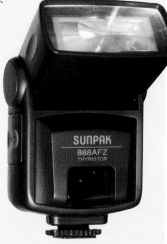

296 Diffusers

Diffusers increase the relative size of the light source, similarly creating a soft quality light from a direct light source. Diffusers can be a simple, translucent plastic cover that fits directly over the flash head, or a larger, more sophisticated gadget resembling a scaled-down version of a studio soft box.

297 Make your own diffuser

Make your own diffuser using a suitable framework and some white nylon. Diffusers negate the need to angle the flash by creating a soft quality of light.

Choosing a suitable flash unit

The following hints and tips identify the main considerations when choosing an external flash unit to go with your DSLR camera.

Power

As a general rule, the more powerful the flash unit, the greater the flexibility you have when using it. Power is given in terms of a guide number (GN), which varies depending on the ISO-E rating set. Typically, the greater the GN (with a constant ISO-E value), the more powerful the flash and the greater its range will be.

299 Coverage

Flash coverage determines which lenses are compatible with the flash unit. Most modern flash units have coverage in the range of focal lengths between 28mm and 135mm.

300 Recycling time

Recycling time refers to the speed at which the flash tube recharges after it has been discharged. It is an important factor, particularly when photographing a quick sequence of images, such as when photographing fast-action sports.

301 Automation

Automatic flash units have taken much of the complexity out of flash exposure, and have made life far simpler for the enthusiast photographer. With an automated unit, once the ISO rating is set, the flash will indicate an appropriate aperture setting, depending on flash-to-subject distance. Some of the more sophisticated models even give you a range of apertures together with the range of the flash illumination with each.

302 Dedicated flash

Dedicated flash units communicate directly with your camera, accessing the information they need to calculate the relevant settings independently of the user, setting shutter speed, and adjusting flash output levels depending on the lens aperture set. In order to operate effectively, dedicated flash units must be used with cameras that have been designed to work with them. For example, a dedicated flash unit manufactured by Nikon will not work properly on a Canon camera, and vice versa.

Tips for using flash indoors

303 Bounce it

Bounce flash-emitted light off a light-colored wall or ceiling to soften the quality of the light and avoid harsh shadows.

304 Metering

Set the metering mode to multi-segment metering.

305 Distance

Make sure your subject isn't too close to the flash unit. Check the exposure using the histogram and, if overexposed, stand further back or reduce the flash power output using flash exposure compensation.

Tips for avoiding red eye

 Flash sync

Use the red-eye reduction flash-sync mode.

 Diffuser

Use a diffuser to turn the source of light from direct (hard) lighting to omnidirectional (soft) lighting.

308 Bounce the light

Don't point the flash directly at the subject. For example, bounce the light off a wall, just as you did to avoid harsh shadows.

309 External unit

Use an externally mounted flash unit, angled at about 45 degrees to the subject.

Tips for using flash outdoors

 Distance

Make sure the subject isn't too distant from the camera. Check the exposure using the histogram and, if the photograph is underexposed, move closer or increase the flash power output using flash exposure compensation.

 Focal lengths

Make sure that the focal length of the lens is within the range of the flash unit. If not, switch lenses.

312 Auto

Use the auto flash exposure with multi-segment metering when using the flash as a fill-in light.

 Power

When using flash extensively away from a power source, use an external battery pack to maximize usage and recycling times.

Useful accessories

Buying wisely
It's possible to spend a small, or even a large, fortune accessorizing your DSLR camera. This section identifies some of the more useful gadgets that you might consider investing in.

Choosing a portable storage device

314 Portable storage devices

If you take a lot of pictures at any one time and away from your home base or without easy access to a computer, a portable storage device, such as a portable hard disk, iPod, or CD/DVD writer, will enable you to download images from the memory card and save them in a safe, permanent, or semipermanent state. This is especially useful when using your camera on holiday, for instance.

315 Reliability

If you intend to travel extensively, and rely on this device for storage, then choose one of the more ruggedly built units, such as the Jobo ViewPro. Review the test reports in photographic magazines for an assessment of the reliability of different units.

316 Capacity

Portable HDDs come with varying capacities, typically from 20GB to 100GB and more. To assess how much capacity you might need, think in terms of the number of images you take during a typical trip. A 20GB HDD will hold the images from 20 1GB memory cards. If you frequently take more images than this–as you might during a long holiday–then choose a device with greater capacity.

317 CD/DVD readers

The capacity of a CD or DVD writer is limited by the size of the disk, typically about 700MB for CDs, and 4GB for DVDs.

318 Power on the move

If you use your camera often in remote locations, where the electricity supply is not reliable, then an inverter will enable you to charge your camera's batteries and power other electrical devices from a car battery via the cigarette lighter socket.

319 Digital viewfinder

A digital viewfinder connects to the viewfinder of your DSLR, and shows a digital image of the scene seen by the camera. It can be useful on occasions when it is difficult to look through the viewfinder, such as when photographing with the camera close to the ground (e.g. in macro photography).

320 Remote photography with a digital viewfinder

The latest version of a digital viewfinder (Zigview R) has a neat function that detects changes in brightness levels, activating the shutter when this occurs. It is a simple, but not always reliable way to try remote photography of, say, shy animals.

321 Cable release

A cable release is preferable for activating the shutter when the camera is attached to a tripod. It also enables you to fire the shutter from a distance, when it's necessary for you and the camera to be in two different places.

322 Optical filters

There remain occasions when optical filters are a better alternative than replicating the effect of an optical filter digitally.

323 Polarizing filters

Polarizing filters help to saturate bold colors, such as red, green, and blue, make white clouds stand out against a blue sky, and remove unwanted reflections from shiny, non-metallic surfaces, such as water and glass.

324 Graduated neutral density (GNDG) filters

GNDG filters help to manage exposure in certain high-contrast scenes, for example in a landscape where the sky is significantly brighter than foreground.

326 Close-up attachments

These items look like filters and attach to the lens in the same way. They are used as an inexpensive route to close-up and macro photography, although image quality is compromised compared with a specific macro lens or bellows/extension tube accessories.

327 Grips

Some DSLR cameras have a variety of optional handgrips available. These accessories make shooting in the vertical format easier, and sometimes include a slot for an additional battery.

328 Underwater housings

It's possible to purchase underwater housings for some DSLR cameras that enable use underwater when diving or snorkelling. They vary in price and complexity, from simple enclosures to sophisticated housings that allow access to all the main camera controls.

325 UV filters

UV filters are clear and absorb ultraviolet light, which can be present at high altitudes and when close to the coast. More significantly, they can be used to protect the delicate front element of a lens from scratching.

329 Lensbabies

A lensbaby brings one area of the picture into sharp focus, with that area surrounded by graduated blur, glowing highlights, and subtle, prismatic color shifts.

330 External battery packs

If you're using your camera for long periods away from a power source, an external battery pack will extend your available shooting time. Some are housed in optional handgrips.

331 Memory card holder

These simple and inexpensive accessories are ideal for holding memory cards safely and securely. They hold multiple cards of any capacity, keeping all your memory cards in one place.

332 Camera bags and cases

There are any number of bags and styles of bags for carrying photographic gear. Backpacks are ideal for trekking, while hard cases are good for transporting delicate equipment in aircraft. Smaller pouches are useful for carrying a minimal amount of equipment when traveling light.

333 Camera bag systems

There seems to be a system for everything these days, and camera bags are no exception. Lowepro has a modular system that enables the attachment of various pockets and pouches for different accessories to a main harness. Similar systems are available from other manufacturers.

334 Waterproof bags

Anyone using camera equipment on the water will want to invest in a waterproof bag. These are available in various styles, from full backpacks to simple watertight pouches, similar to those used by canoeists and kayakers.

Different subjects

Get creative
Digital SLRs are ideal for shooting a wide variety of pictures that have real impact and professionalism. First, here are some hints and tips for getting the most out of your formal and informal portraits.

335 Recommended camera settings

For general photography of people, use the following camera settings and lens data as a guideline:

Metering mode: aperture-priority auto
Exposure mode: center-weighted
AF mode: single-servo AF
Shooting mode: single-frame advance
WB: set per lighting conditions (or Auto WB)
ISO-E: 100-200
Lens focal length: 85-105mm

337 Set AE to aperture priority

To obscure distracting background clutter, select aperture-priority AE mode, and set a large aperture (around f/2.8 or f/4). The resulting lack of depth of field will cause background detail to appear blurred, helping to isolate and draw attention to your subject.

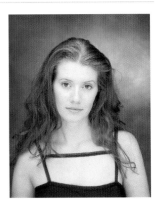

336 Check the whole viewfinder

Make sure you check all areas of the viewfinder to identify any distracting objects in the foreground, at the edges of the frame, or in the background. Remember that most DSLR cameras have a viewfinder with only 93-95% coverage, so some areas of the scene that will appear on the image won't be seen through the viewfinder.

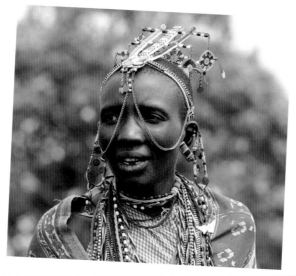

338 Zoom in

If you are using a wide-range zoom lens (e.g. 28-300mm), set the focal length to about 100mm to crop closely around your subject. If you have only prime lenses, then select a lens with a focal length of between 80mm and 135mm to achieve the same effect.

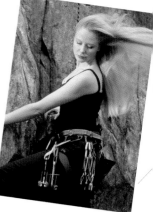

339 Composition

Positioning the subject in the center of the picture will isolate it from the background. Composing the image with the subject to one side, creates a more dynamic scene and adds emphasis to the surroundings.

340 Beware of shadows

When photographing people outdoors in bright, overhead sunlight, unflattering shadows are likely to form under the forehead, nose, and chin. This is particularly true with a point-and-shoot approach to photography. If it's impossible to move your subject to a different spot with softer lighting, then use the pop-up flash on the camera (or an external flash unit) to add some fill-in flash, which will lighten the shadow areas.

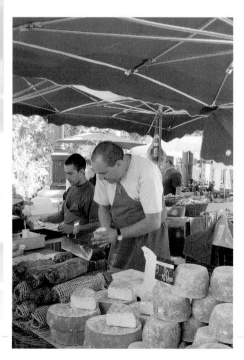

341 Overcoming red eye

Avoid red eye by using a flash that is positioned to one side of the camera, rather than on top. If you have access only to the pop-up flash built into the camera, use the red-eye setting on the camera's flash mode (if it has one) or, as a last resort, cover the flash with an opaque material, such as a handkerchief, which will scatter the direct light, making it softer in quality.

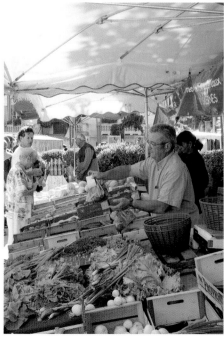

342 Posing

People often feel uncomfortable when posing for a photograph, particularly when confronted with a "professional" camera. They become self-conscious, tense, and, most obviously, are never sure what to do with their hands. First of all, help them to relax by talking to them, making them laugh, or doing anything that will take their mind off what they are doing. The hands need to fall naturally into place. Alternatively, give your subject something to hold.

343 Facial expressions

Watch for any candid moments when your subject shows emotion through facial expressions, such as laughter or a mischievous look. Have the camera ready to point and shoot with a wide aperture and fast shutter speed set to ensure you capture the moment with no image blur. Crop tightly around the face and head, using a short telephoto lens or zoom setting, to maximize the impact of the expression.

344 Supporting the camera

For formal portrait photographs it's best to attach the camera to a tripod. When photographing candid images you may find it easier to hand-hold the camera. Alternatively, a monopod is a good compromise.

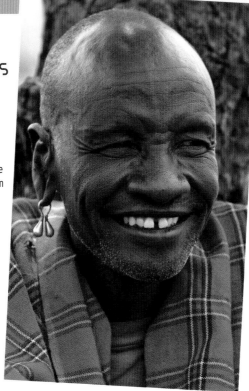

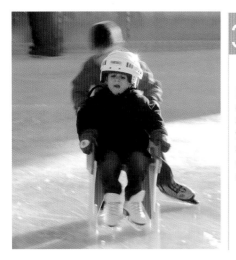

345 Capturing the essence of youth

In most instances, children are photographed best when going about their normal lives—playing in the garden, at a park, eating, and so on. Be prepared to move around with your camera rather than stand in a single place. Using flash will help to freeze any rapid action, and attaching a zoom lens will enable you to get the best composition. When trying to get unruly kids to sit and pose for a picture, distract them with talking or hand gestures.

346 Recommended camera settings

For general photography of children, use the following camera settings and lens data as a guideline:

Metering mode: aperture-priority auto
Exposure mode: multi-segment AE
AF mode: continuous-servo AF
Shooting mode: slow multi-frame advance
WB: set per lighting conditions (or Auto WB)
ISO-E: 100-200
Lens focal length: 50-105mm

347 Set up a simple home studio

For professional-looking portraits, set up a simple home studio. Choose a room with some space and use a plainly decorated wall or plain curtains as the background. A stool can be used to allow your subject to sit and pose, and the scene lit by shining a spotlight through a large linen or cotton sheet. If using tungsten lighting (e.g. a household lightbulb), remember to set the WB accordingly.

348 Selecting the point of focus

There's really only one point on which to focus the lens, and that's the eyes of your subject. The eyes are the most important aspect of any portrait to get sharp, whether the subject be a person or animal. For critical focus, I recommend focusing manually rather than relying on autofocus.

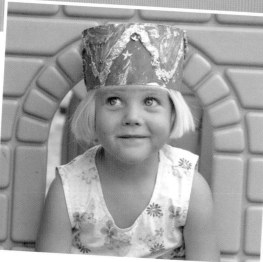

Isolating your subject

You can focus attention on your subject by placing them within their own frame, such as a door or window. Compositionally, this technique works in the same way that framing a photographic print makes the print look better. Natural frames outdoors are overhanging branches of a tree, an archway, or similar object.

350 Advanced lighting effects

Rather than the standard approach to lighting, photograph your subject with the sun behind them to create rim lighting or a silhouette. For rim lighting, avoid having the sun directly in the picture, and expose for the subject. You will need to use the spot-metering mode and take your meter reading from the subject. For a silhouette effect, set the exposure for the highlights by framing the scene with just the sky visible in the viewfinder. Then, use the AE-Lock button or function to lock the exposure before reframing the scene with your subject in the picture.

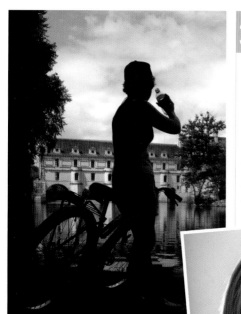

351 Outdoor lighting

Avoid photographing your subject in direct sunlight in the middle of the day. An overcast day will produce a better quality of light for subtle skin tones with no harsh shadows. For an image with more contrast, but maintaining nice lighting, I recommend photographing in the early morning on a clear day.

352 Soft-focus lenses

Some camera manufacturers, such as Nikon, produce specialist lenses for portrait photography that purposely produce a soft effect to the recorded image. These lenses are known as soft-focus lenses and are ideal for subtle portraits shot in a formal style.

353 Soft-focus effects without specialist lenses

You can produce a similar effect to that created by soft-focus lenses by smearing a light layer of Vaseline onto a UV filter and attaching the filter (Vaseline-side facing out) to the lens. The thicker the layer of Vaseline, the more pronounced the effect, although too much will just obscure the subject altogether.

355 Select the appropriate flash-sync mode

We've previously outlined the various flash-sync settings available on DSLR cameras, and it's important that you select the appropriate mode when using flash to photograph people. The standard (default) setting is suitable for most situations. However, in low light the lack of ambient light can cause backgrounds to underexpose to the extent that they appear black. In this instance, set Slow-sync mode. The extended shutter speed times available will enable exposures that balance the flash and ambient light for more natural-looking images.

356 Slow-sync flash mode and red-eye reduction

Slow-sync flash mode can be combined with red-eye reduction to minimize the likelihood of red eye occurring.

354 Use an external flash for better fill-in flash results

The small built-in flash on your DSLR is suitable for point-and-shoot photography but is limited in its potential. DSLR cameras have sophisticated flash-metering systems that enable external flash units to be used for fill-in flash without the need to understand complex lighting and exposure formulas. Add an external flash unit to your kitbag, and let the camera do the rest.

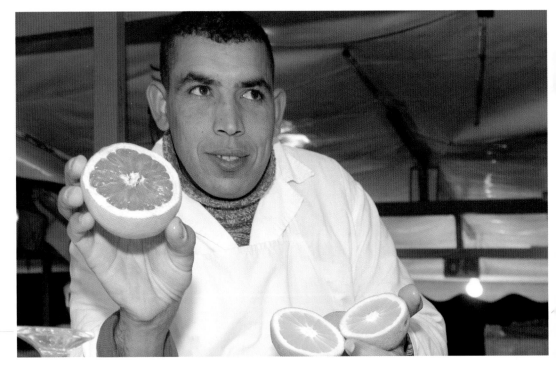

Tilt and swivel flash

Many external flash units have the capability of tilting and/or swivelling the head in order to bounce the light off a light object (e.g. a wall or ceiling) to produce a softer quality of light. If you have to make use of the built-in pop-up flash, then cover the front of the flash with a thin material to achieve similar results.

358 Self-portraits

Use the self-timer on the camera to make sure you're not missing from your family portraits and vacation pictures. Compose the picture first, leaving enough room on one side to join in after pressing the shutter release. Most cameras let you alter the length of time the self-timer waits before activating the shutter, so make sure you've got enough time to get into the picture and settle down. After the picture is taken, check the composition via the LCD screen to make sure you haven't cropped too tightly.

Recommended camera settings

For general photography of self-portraits, use the following camera settings and lens data as a guideline:

Metering mode: aperture-priority auto
Exposure mode: multi-segment AE
AF mode: single-servo AF
Shooting mode: self-timer (10-20 sec delay)
WB: set per lighting conditions (or Auto WB)
ISO-E: 100-200
Lens focal length: 50-105mm

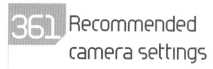 Spontaneity

Take your camera out and about with you and keep your eyes open for candid moments of photographic interest. Keep the camera turned on and select the settings most suitable for point-and-shoot photography (see tip 361). Attach a short telephoto lens or zoom lens of between 80mm and 200mm focal length. Great places for candid photography are markets, lively streets, town centers, sports events, weddings, and other celebrations.

361 Recommended camera settings

For general photography of candid portraits, use the following camera settings and lens data as a guideline:

Metering mode: aperture-priority auto
Exposure mode: multi-segment AE
AF mode: continuous-servo AF
Shooting mode: slow multi-frame advance
WB: set per lighting conditions (or Auto WB)
ISO-E: 100-200
Lens focal length: 50mm-200mm

Warning!

In many cultures, it is polite to seek permission before taking a photograph. Always research local customs before taking photographs overseas.

Landscapes

 Recommended camera settings

For general photography of the landscape, use the following camera settings and lens data as a guideline:

Metering mode: aperture-priority auto
Exposure mode: spot
AF mode: manual
Shooting mode: single-frame advance
WB: Cloudy
ISO-E: 100
Lens focal length: 17-35mm

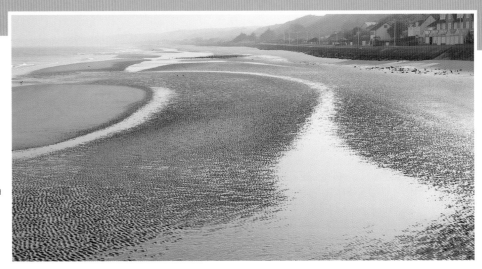

 Depth-of-field preview button

Many DSLR cameras have a depth-of-field preview button that enables you to assess depth of field accurately before the image is taken. Use it when taking landscape images to check that foreground and background detail is sharp.

 Not enough depth of field?

If depth of field doesn't extend to the closest and farthest objects, consider setting a smaller lens aperture. Set the exposure mode to either aperture-priority AE or manual, and select an aperture of between f/16 and f/32.

 The sky's the limit

If the sky is going to be visible in your picture, then it should add interest. Avoid scenes where the sky is plain. Instead, wait until there are interesting cloud formations. If time is of the essence and you can't wait for a photogenic sky, angle the camera to remove as much of the sky from the picture frame as possible.

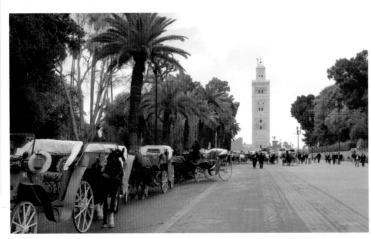

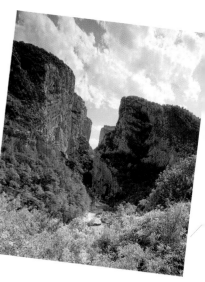

367 Composition

Landscape photographs should "read" like a story, with a beginning, middle, and end. Look for foreground interest, such as a line of fencing, boulders, or driftwood that will lead the viewers' attention to the main subject. The background (the end of the visual story) should be interesting and complementary, and show sharp detail.

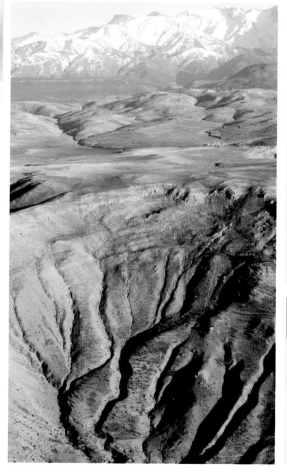

368 Vertical versus horizontal format

Holding the camera in the vertical or horizontal format alters the emphasis on the subject in the frame. A vertical composition emphasizes height and is ideal for pictures of tall structures, such as trees and skyscrapers. A horizontal composition emphasizes space and is used widely in landscape photography.

369 Add a vertical grip

Some DSLR cameras have an optional vertical grip that makes photographing in the vertical format easier. These grips have shutter and exposure controls built in, and provide additional battery space, allowing for longer sessions between changes.

370 The rule of thirds

The rule of thirds is a useful technique to use in landscape photography. Divide the picture frame into equal thirds both vertically and horizontally. For a compositionally strong and dynamic image, position the subject where the dividing lines intersect.

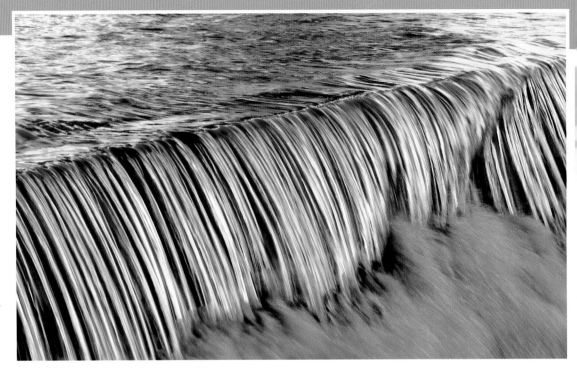

371 Switch on the electronic grid

Some DSLR cameras have an electronic viewfinder grid that can be switched on and off in the menu options. When taking landscape or architectural photographs, switch this grid on to help with applying the rule of thirds, as well as helping to keep horizon lines level. The rule of thirds divides an image into a grid of nine squares. Positioning subjects at any intersection of these lines can create powerful compositions.

372 KIS—keep it simple

Avoid the temptation to cram too much into the picture space. Too many competing objects detracts from the visual impact the photograph could make. There should be a single main point of focus, and all other objects in the picture space should complement the main one.

373 Always use a tripod

Even if you think you have a steady hand, you should always use a tripod to keep the camera still and avoid image blur caused by camera shake. Because digital SLRs often weigh more than similar film cameras, and are heavier than compacts, it is essential that you use a tripod designed to carry the full load of the camera and lens.

374 Avoiding stasis

Landscapes are by nature static, but you can make your landscape pictures appear energetic by using clever compositional techniques and design. Diagonal lines, asymmetry, and combining complementary colors (e.g. red and green, blue, and orange) all create a sense of visual energy and make pictures more dynamic.

375 Learn about weather

Weather plays a large part in landscape and outdoor photography, and so it makes sense to gain a basic grasp of forecasting. You will save a lot of time, effort, and money by heading out on the days you know will provide good light or the right conditions, rather than trusting to luck.

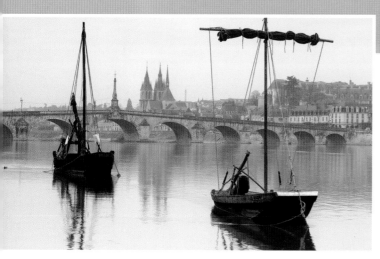

378 Beware vignetting

Vignetting is caused by a marked fall-off of light at the corner of the frame, and is usually caused by light being blocked by a lens attachment such as a filter or lens hood, particularly when using a wide-angle lens. Check the viewfinder to assess whether vignetting is occurring and remember to take account of the slight cropping that occurs with most DSLR viewfinders (not those in some professional models), which have less than 100% coverage.

376 Bad weather photography

Great landscape photographs don't necessarily need sunshine. In fact, some of the best landscape photography can be achieved when the weather is inclement. Stormy weather, lightning, thick rolling clouds, and rainbows can also be excellent subjects for the landscape photographer.

379 Positioning the horizon line

Where you position the horizon line in the picture space will alter the emphasis of the image. With the horizon centrally positioned, equal weight is given to both background and foreground. To emphasize the foreground of a scene, position the horizon line in the top third of the frame. To emphasize the background, position the horizon in the bottom third.

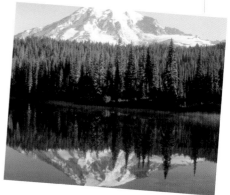

377 Use a lens hood

Shooting into the sun can cause lens flare to occur, particularly when using wide-angle or telephoto lenses. Always use a well-designed lens hood, preferably one that is designed specifically for the lens being used.

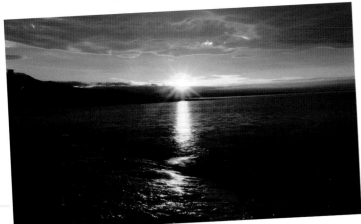

380 Straight and level horizons

In most instances, landscape images should have a straight and level horizon line. Use the auto-on gridlines that are available with some DSLR cameras to help keep the camera level. Alternatively, attach a spirit level to the accessory shoe, or use the built-in spirit level that is present on many high-end tripods.

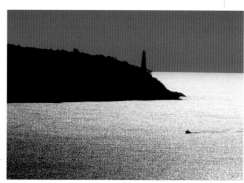

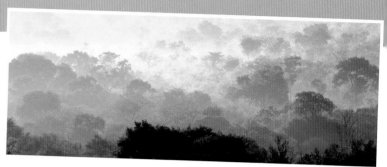

381 Deep and meaningful

Isolate converging lines, such as the flow of a river or even a road, to add a sense of depth to your landscape photographs. Contrast also helps to add form to images, which is a good reason for photographing landscapes when the sun is low in the sky.

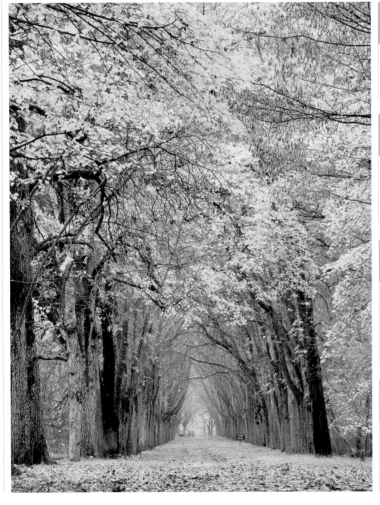

382 Be an early bird

They say the early bird catches the worm, and it is true that early morning is an ideal time for landscape photography. The air is clean and clear, the sun is low to the horizon, color temperature is warm, and there are usually few people around.

383 Sunsets and silhouettes

Sunset is also a good time of day for landscape photography for reasons similar to early morning. This is also a good time to create striking silhouettes. Switch the metering mode to spot-metering and take a reading of the bright sky behind your subject. Using the AE-Lock button/function, lock the exposure and recompose to take the image.

384 Optimizing the camera for landscape photography

For quick landscape pictures that look good straight from the camera, use the optimization menu option to automatically select the most appropriate menu settings.

385 Warming up

When photographing about one hour after sunrise and one hour before sunset, set the camera's WB to the cloudy setting to give your images a warm cast. It's a technique that replicates using a warming filter.

386 Add some punch

Select the appropriate sRGB color mode via the menu to make landscape colors appear more vivid. Additionally, use a polarizing filter to saturate bold colors (e.g. red, blue, and green), to make white clouds stand out against a blue sky, and to remove reflections from non-metallic surfaces, such as water.

388 Other landscape filters worth having

A set of neutral-density graduated and nongraduated filters are a worthwhile investment, as is a UV filter for photographing at high altitude or by the coast. A UV filter also helps to protect the front lens element from damage.

389 Use the B&W setting

Some of the more recent DSLR cameras now enable taking digital pictures in black and white via a B&W setting in the menu options. When shooting in B&W mode, select a high level of contrast via the tone control to add to the impact of your black-and-white images.

390 Auto-bracketing

In situations where the light is changing frequently, or when accurate metering is difficult, use the auto-bracketing function to ensure you get a well-exposed image. Select either 3-frames at +0.5-stops or 5-frames at +1- and +0.5-stops.

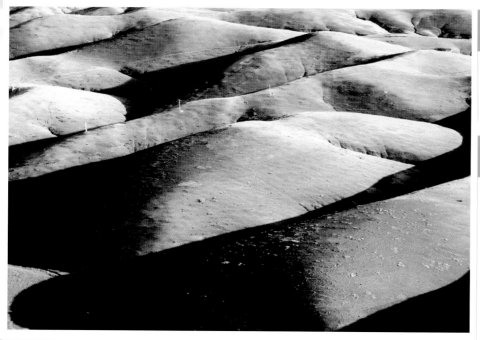

387 Choose the right polarizer

There are two types of polarizing filter (linear and circular), but only circular polarizers work effectively with the AE and AF systems used by DSLR cameras.

Pets, animals, and wildlife

391 Recommended camera settings

For general photography of pets, animals, and wildlife, use the following camera settings and lens data as a guideline:

Metering mode: shutter-priority auto
Exposure mode: multi-segment AE
AF mode: continuous-servo AF
Shooting mode: fast multi-frame advance
WB: auto WB
ISO-E: 200-400
Lens focal length: 200-500mm

392 Use a telephoto lens

Typically you will want to attach a long telephoto lens for photographing animals and wildlife. There are some versatile zoom lenses on the market for all budgets (e.g. 70-300mm, 80-400mm, 100-400mm, 120-300mm).

393 Add a teleconverter

If a long telephoto lens is beyond your budget, then a teleconverter is a less expensive alternative. This accessory fits between your lens and your camera, and increases its effective focal length by a given multiplication factor, usually 1.5x, 1.7x, 2x, or 3x. For example, a 200mm lens with a 2x converter would have a focal length of 400mm.

394 Aperture, size, and weight

Long telephoto lenses with fast apertures are large, heavy, and expensive. You will nearly always need to use them in conjunction with a tripod. Lenses with slower apertures (e.g. f/5.6) are much smaller, lighter, and easier to use. The downside is the loss of stops.

395 Beanbags

It's sometimes not possible to use a tripod when photographing wildlife. A suitable alternative is a beanbag. Fill the beanbag with a natural ingredient, such as maize or rice, and it will support your camera, keeping it steady, and absorb vibrations.

396 Set shutter-priority AE for action

To capture action shots of animals with fine detail, set AE mode to shutter-priority and select a fast shutter speed (about 1/500 sec or faster). Pan the camera to follow the movement of the animal.

397 A sense of motion

Alternatively, for a greater sense of motion, select a shutter speed of about 1/30 sec to create speed blur, which adds to the atmosphere of a picture. Pan the camera to follow the movement of the animal.

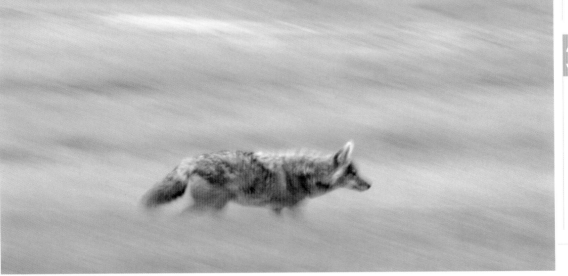

398 Set AF to continuous

To keep the subject in focus, set the AF mode to continuous servo (AI-servo) to enable the camera to track the movement of the animal, and adjust the focus point accordingly.

399 Use the ISO-E control for faster shutter speeds

If the light level is too low to enable setting a fast shutter speed, even with the aperture wide open, then consider increasing the sensitivity of the sensor using the ISO-E control. Increasing ISO-E from 100 to 400 will give you two extra stops of light to play with, potentially changing a shutter speed of 1/125 sec to 1/500 sec.

400 The point of focus

It's important when photographing animals to focus on the eyes. Select continuous AF mode with wide-area AF to increase the likelihood of the camera focusing on the right point. Make sure that the active AF sensor is covering the eye. Alternatively, with stationary animals, switch to manual focus and do it yourself.

401 Depth of field

Extensive depth of field is less critical in wildlife photography than in, say, landscape, but you will need enough depth of field to ensure the eyes and nose appear sharp. When using telephoto lenses, this becomes more difficult to achieve. In general, an aperture 2- to 3-stops closed from maximum (e.g. f/5.6-f/8 on an f/2.8 lens) will be sufficient.

 ## Good field practice

Never disturb animals with young, and always return any environment you've disturbed to its natural state. If an animal appears agitated then slowly and quietly move away. Many countries have laws that extend to wildlife and the countryside, and you should make sure you are aware of them before venturing out.

403 Use a hide (blind)

To get close to wild animals, particularly birds, without disturbing them, use a hide (blind). These can be purchased ready-made or you can build your own.

404 Image sequences

Set the drive mode to continuous (fast continuous if your camera has the option) to capture a sequence of wildlife images. When taking several pictures in succession, watch the burst-rate to ensure your shutter doesn't go into lock-out.

 ## A simple camera trap

Use the Zigview viewfinder attachment to make a simple camera trap, and let the wildlife take its own picture. Make sure your camera is safe before leaving it.

Animals in zoos

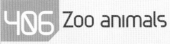 ## Zoo animals

Zoos and safari parks are easily accessible for animal photography. Beware of background distractions (e.g. people, cars, fences) that detract from the "natural look" of the image. Check the picture on the LCD screen after taking to make sure you haven't caught any unwanted detail.

407 Recommended camera settings

For general photography of animals in zoos, use the following camera settings and lens data as a guideline:

Metering mode: aperture-priority auto
Exposure mode: multi-segment AE
AF mode: continuous-servo AF
Shooting mode: slow multi-frame advance
WB: auto WB
ISO-E: 200–400
Lens focal length: 100–300mm

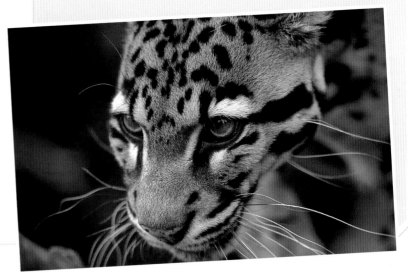

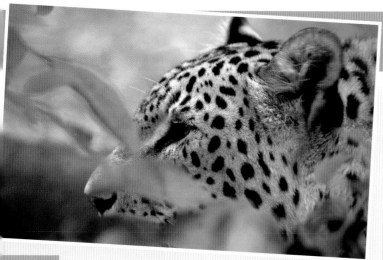

411 Turn off the flash to photograph through glass

If your DSLR has a pop-up flash, it may automatically activate in low-light conditions, such as when photographing indoors. If you are trying to photograph through glass, the flash will bounce of the glass and produce flare, spoiling your picture. Turn the auto-flash off in the menu settings, if your camera allows it.

408 Perspective

Animals rarely look good when photographed from above. Get low down and photograph them at eye-level whenever possible. This will produce a far more engaging composition and natural perspective.

409 Take a macro lens

You can get much closer to animals in captivity than you can in the wild. Change your usual lens for a macro lens, and focus your attention on the fine detail, such as patterns on fur, the eyes, paws, and so on.

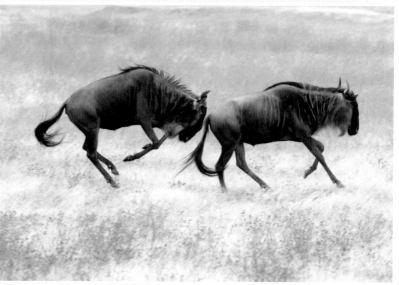

410 Shooting through wire

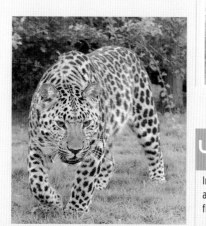

Choose a telephoto lens and set the aperture to its maximum setting (largest hole). Hold the camera parallel to, and right against, the fence, with the center of the lens pointing through the hole in the wire. In most cases, the wire will appear so far out of focus you won't see it at all.

412 Adding catchlights

In overcast conditions, use the built-in pop-up flash on your DSLR to add a catchlight to animals' eyes. If your camera has no built-in flash, add a small external flash unit.

413 When to press the shutter

When is it the right time to press the shutter? This is a question every photographer asks. Here's a little trick to help you decide. When looking through the viewfinder at the scene, ask your self the question: "How would I caption this photo?" If the only caption you can think of is the species name, then the picture probably isn't worth taking. Look for actions, behavior, and expressions (humor, interaction, bonding, etc.) that capture the essence of the subject.

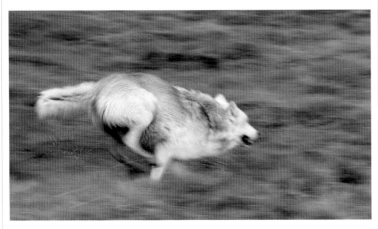

Close-up and macro

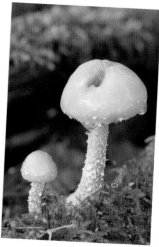

414 Recommended camera settings

For general close-up and macro photography, use the following camera settings and lens data as a guideline:

Metering mode: aperture-priority auto
Exposure mode: multi-segment AE
AF mode: manual
Shooting mode: single-frame advance

415 Choose the right close-up accessory

There are several accessories available to add to your DSLR for close-up and macro photography. The least expensive option is a close-up attachment lens, which looks much the same as a filter. The most convenient accessory is a purpose-made macro lens, which can reproduce subjects up to lifesize. The most versatile option is a set of extension bellows.

416 Macro flash units

There are special flash units available to add to your DSLR camera for macro and close-up photography. Ring flash units are easy to use and versatile, although they can be expensive. A twin-head flash setup can be put together at less cost.

417 Close focusing

Close focusing isn't always considered when buying lenses but is essential for successful macro photography. Avoid lenses that have long closest-focusing distances.

418 Set focus to manual

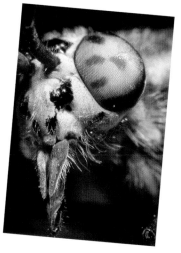

Manual focus is by far the best and most accurate means of focusing the lens during macro photography. Use the focus indicator light in the viewfinder to confirm that the camera has focused the lens before pressing the shutter.

419 Use depth-of-field preview

If your camera has a depth-of-field preview button, use it to assess how much of the area in front of and behind the point of focus appears sharp.

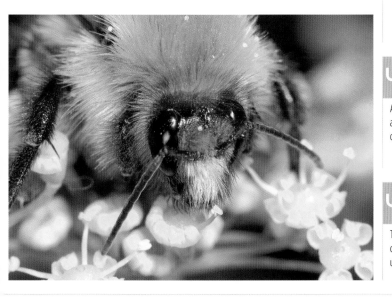

420 Set aperture-priority AE

Because depth of field is critical at such short camera-to-subject distances, it must be managed effectively. Switch the exposure mode to aperture-priority AE and set a narrow aperture (e.g. f/11 or smaller) to maximize depth of field.

421 Parallel lines

Once the camera is focused, any subject along the plane of focus will appear sharp. Keep the camera parallel to the subject to maximize image sharpness.

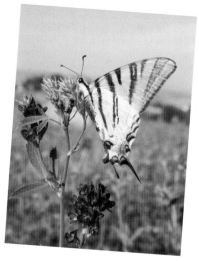

422 Minimize camera movement

At such high levels of magnification, even the slightest camera movement can ruin an otherwise good picture. Use a tripod or table clamp to secure the camera and avoid camera shake. There are special tripods suitable to macro photography specifically.

423 Mirror lock-up

The vibrations of the reflex mirror flipping up out of the way of the shutter and sensor can cause images to blur. If your camera has an appropriate mirror lock-up function, use it before you take the picture.

424 When mirror lock-up isn't mirror lock-up

Some DSLR cameras have a function called Mirror Lock-up that is used to lock the mirror out of the way for cleaning the sensor. This function is not the same as an operational Mirror Lock-up function for use during photography.

425 Create a macro studio

Many macro subjects can be photographed inside equally as well as outdoors. A macro studio needn't take up much room, requiring a solid table, a camera support, a prop for the subject, low-powered lighting, and a suitable natural-colored background.

426 Weather

Bright sunlight isn't always conducive to good macro photography outdoors. Overcast conditions can provide better lighting, reducing levels of contrast.

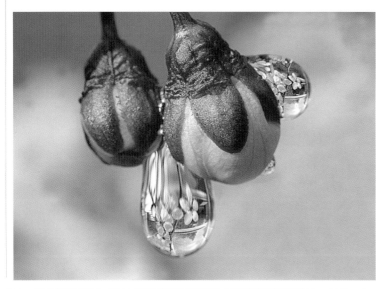

427 Background detail

Using flash at close quarters is likely to result in an underexposed background, rendering it almost black. This is OK for isolating the subject and for emphasizing certain features, such as line or shape; however, it looks unnatural. To brighten the background, set the camera to slow-sync flash mode, which will allow more of the ambient light to register on the sensor.

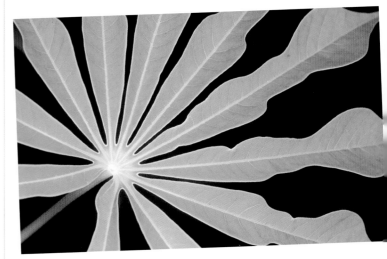

428 Macro subjects

The macro world is hidden from our everyday view of nature and the environment—that's what makes it so exciting. Texture, patterns, shapes, and colors all make fascinating macro subjects, which will reveal to you and your friends worlds previously unseen.

Night and low light

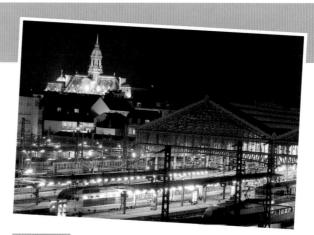

429 Recommended camera settings

For general photography at night or in low-light conditions, use the following camera settings and lens data as a guideline:

Metering mode: aperture-priority auto
Exposure mode: multi-segment AE (or spot)
AF mode: single-servo AF (or manual)
Shooting mode: single-frame advance
WB: incandescent (where there are numerous street lights), fluorescent (at stadiums), auto WB (for unlit scenes)
ISO-E: 400 (going to 800 in exceptional circumstances)
Lens focal length: depends on the subject

430 Preprogrammed night exposure modes

Beware of using the camera's preprogrammed night-exposure modes. They will give acceptable results in general situations, but may not always be suitable for what you're trying to achieve. Even when using these settings, always use a tripod to minimize the likelihood of camera shake.

431 Use the Bulb (Time) shutter-speed setting

DSLR cameras have a shutter-speed setting known as Bulb or Time. This setting enables shutter speeds in excess of the camera's preset maximum (usually around 30 sec) up to several minutes or hours. Use this setting when very long exposures are necessary.

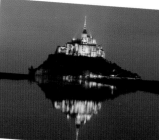

432 Beware of noise

During very long exposures, the build-up of noise may be so great that the noise reduction function is only partially successful at removing it.

433 Increasing ISO-E (sensitivity)

If it's so dark that you're struggling to get a workable exposure, increase the sensitivity of the sensor using the ISO-E control. A shutter speed of 8 sec can be reduced to 1/2 sec by changing the ISO-E rating from ISO-E 100 to ISO-E 1600.

434 The advantage of fast lenses

The faster the lens the more control you will have over exposure settings. For example, a lens with a maximum aperture of f/2 is 3-stops faster than a lens with a maximum aperture of f/5.6. These three stops can turn a noise-generating shutter speed of 2 sec to a more acceptable 1/4 sec.

435 Use the background light (and take a torch)

Use the background light facility to light the LCD screen on the camera when photographing in the dark. It's also worthwhile taking a torch to help illuminate the dials and controls on the camera, rather than working "blind."

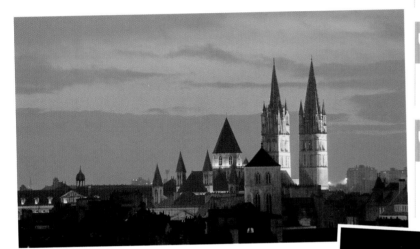

436 Focusing in the dark

Autofocus is less efficient at night, particularly those systems that use contrast detection to assess subject distance. The lack of contrast in low light often causes AF to go into hunt mode. Look for a bright area of the scene close to your main subject, such as a street lamp or a lit window, and use that as the point of focus. If that fails to solve troublesome AF, switch to manual focus mode.

437 Auto-bracketing

If you use the auto-bracketing function on your DSLR at night, make sure that the exposure mode is set to aperture-priority AE, so the camera only adjusts aperture and not shutter speed.

438 Use a spirit level to check horizon lines

If you are photographing a night scene that includes a horizon, use an attachable spirit level secured in the accessory shoe to accurately level the camera.

439 Shield the viewfinder eyepiece

During long-time exposures, you should shield the eyepiece to prevent stray light from affecting the AE metering and setting inappropriate exposures.

440 Safety first

Your safety and the security of your equipment should be paramount in your mind when photographing at night in quiet, built-up areas and even in busy centers, as well as remote locations. If possible, always go with a friend or colleague.

441 Moonlight

When using moonlight as the main light source, set a shutter speed of around 4 min when the moon is full and the sky clear. Double the amount of exposure when the moon is partial. To photograph the moon itself, use a long telephoto lens and set an exposure of around 1/1000 sec @ f/8 with an ISO-E of 400.

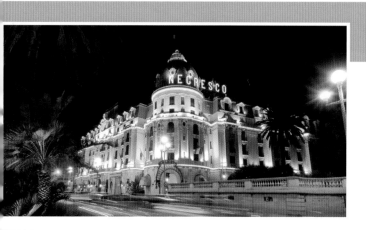

442 Streaked lighting

To create streaks of light from moving cars, set the camera on a tripod, manually focus the lens, and set an exposure of between 10 sec and 20 sec at f/22 (ISO-E 400). Use the Bulb (Time) setting if necessary, and activate the shutter using a cable release.

443 Lightning and fireworks

Firework displays and electrical storms are incredible photographic subjects. Manually focus the lens on infinity and set the lens aperture to around f/8. Vary the length of your exposures to change the effect. Exposures of several minutes may capture multiple lightning flashes or bursts of fireworks.

444 Star trails

Star trails make fascinating pictures and are a lot of fun to attempt. Set the camera on a tripod and set the shutter speed to Bulb (Time) setting. You will need a cable release that has a timer or can be locked in the down position. Your exposure needs to last for a minimum of 4 hours and up to 8 hours. Set an aperture of around f/8 and ISO-E to 200. If you are considering leaving your camera for any length of time, make sure it is secure.

445 Funfairs

To capture the thrill and excitement of a funfair, set the AF mode to continuous and select an exposure of around 1/125th sec @ f/2.8 (ISO-E 400) to freeze movement, or 1/15th @ f/8 (ISO-E 400) to create motion blur and a sense of visual energy. Use a zoom lens to alter your perspective on the scene.

446 Cityscapes

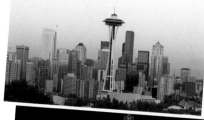

City buildings lit at night can be photographed close-up or as part of a wider scene. Light from the buildings should mean that AF works effectively. Exposures will vary from around 2 sec at f/11 for a tightly cropped scene, or 8 sec at f/11 so that the city forms part of a wider landscape. Cityscapes often look best when photographed from a high vantage point, such as from a balcony on a tall building or from a high, distant hill. If buildings are floodlit and photographed with a tight crop, increase the shutter speed to ÷-1 sec.

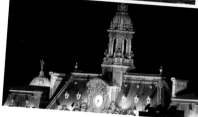

447 Street scenes

Street scenes and street lighting can make for atmospheric photographs. Set the WB to Incandescent (tungsten) to compensate for the street lighting. A slow shutter speed of around 1/4 sec will be long enough to blur the motion of people walking in the scene without losing them altogether (aperture around f/8 and ISO-E 400).

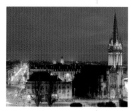

448 Cable release

Whenever you use your camera with a tripod, you should always remotely fire the shutter using a manual or electronic cable release to prevent camera movement during exposure.

Sport

449 Recommended camera settings

For general photography of sports, use the following camera settings and lens data as a guideline:

Metering mode: shutter-priority auto
Exposure mode: multi-segment AE
AF mode: continuous-servo AF
Shooting mode: fast multi-frame advance
WB: auto WB (in daylight), fluorescent (in lit stadiums at night)
ISO-E: 200-400
Lens focal length: 200-500mm

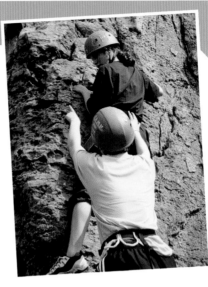

452 Use a zoom lens

A zoom lens with a range of between 100-400mm enables you to select the best composition without having to continually relocate your position, which can be difficult or impossible at some events.

450 Be prepared

By definition, sport is unpredictable, which means you have to keep your wits about you to avoid missing the action. Don't crop so tightly that any movement of the subject is liable to position them outside of the frame. Keep your finger ready on the shutter release, and be alert to the action as it plays out on the field or track.

453 Hand-holding and image-stabilizing technology

On many occasions, it's easier to hand-hold the camera when photographing sporting action. Consider acquiring one of the new generation of lenses with built-in optical stabilization technology (VR for Nikon, IS for Canon, and OS Sigma), which reduces the effects of blur caused by camera shake.

451 Isolate the subject

Use telephoto lenses and narrow apertures to minimize depth of field and render background detail blurred. This will help to isolate your subject from distracting objects and events in the background.

454 Camera panning

With moving subjects on a predictable line, use the camera-panning technique to create pin-sharp images with a hint of motion. Set AF mode to continuous and the focus area mode to wide. A fast shutter speed will help freeze the motion of the subject. Follow the movement of the subject through the viewfinder and continue to pan the camera for a short moment after pressing the shutter.

455 Action blur

Alternatively, set a slow shutter speed when panning to create action blur and a greater sense of motion.

456 Do your homework

Great sports photos are often down to good positioning. If you get a chance, check out the location prior to taking pictures and assess the best position for photography. For example, in a stadium, it may be better to be close to the action in the pitch-side seats, rather than high up in the stands, far distant from the action and behind several spectators' heads.

457 High-speed frame advance

Set the camera to continuous frame advance (high-speed setting if it has one) and take several simultaneous pictures of the action to ensure you capture the telling moment. However, remember burst-rate and watch out for shutter lock from excessive exposures.

458 Recommended camera settings

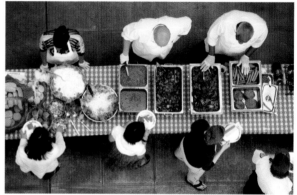

For general vacation and travel photography, use the following camera settings and lens data as a guideline:

Metering mode: aperture-priority auto
Exposure mode: multi-segment AE
AF mode: single-servo AF
Shooting mode: slow continuous-frame advance
WB: set per lighting conditions (or auto WB)
ISO-E: 100-400
Lens focal length: 20-200mm

459 The road less travelled

When on vacation, we tend to think of sandy beaches and historic buildings and monuments as subjects for our photos. Don't limit your photography to the obvious. Attach a wide-range zoom lens (e.g. 28-200mm) and head into the markets, or wander down the out-of-the-way side streets for photographic inspiration.

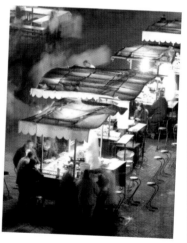

460 Candid camera

People do the most wonderful (or craziest) things when they think no one is looking. Watch out for those special moments and have your camera ready to capture the scene. This might be a time for point-and-shoot photography.

461 Recommended camera settings

For general candid photography on vacation, use the following camera settings and lens data as a guideline:

Metering mode: shutter-priority auto
Exposure mode: multi-segment AE
AF mode: continuous-servo AF
Shooting mode: slow multi-frame advance
WB: auto WB
ISO-E: 200-400
Lens focal length: 100-300mm

462 Zoom out for a sense of place

Select a wide-angle lens or wide zoom setting (e.g. between 18 and 35mm) and move closer to the subject to create a real sense of place. If the subject is in shadow against a bright background, add a burst of fill-in flash to lighten the shadow areas.

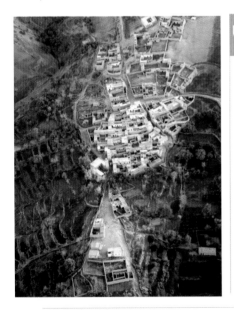

463 The earth from the air

Make the most of an airplane flight by taking some pictures from the airplane's window. Select a wide aperture and set focus to infinity. Keep the lens parallel with, and close to, the window, to avoid reflections and glare. Be aware of the wings, but don't necessarily exclude them—they can add a sense of place. At very high altitude, fit a UV filter to the lens to reduce the amount of UV light entering the camera.

464 Recommended camera settings

For general photography from the air, use the following camera settings and lens data as a guideline:

Metering mode: aperture-priority auto
Exposure mode: multi-segment AE
AF mode: manual
Shooting mode: single-frame advance
WB: auto WB
ISO-E: 200-400
Lens focal length: 100-200mm

465 Composition

Include foreground objects to add interest. Emphasize leading lines that draw the viewer into the picture space. Change camera angle and perspective to alter the relationship between objects and pictorial elements.

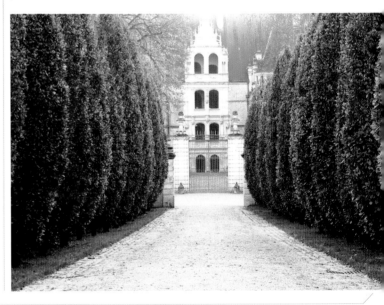

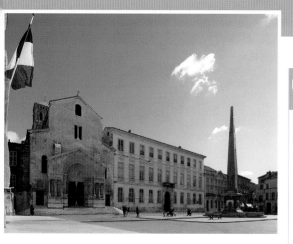

466 Beat the crowds

Rise early to avoid the crowds at popular destinations. Most visitors to the main attractions arrive and leave during the middle of the day. Waking early will reward you with crowd-free scenes and great photographic light.

467 Respect local culture

It is important to respect local culture and traditions. Some people prefer that you seek permission before taking their picture. If in doubt, ask. If refused, accept their wishes gracefully. In some countries taking pictures inside places of worship is forbidden. Always find out first what you can and can't do, and abide by local custom.

468 Photography at airports

With the increasing levels of security around airports, it is unwise to use your camera in or around an airport complex. In some countries, you may find yourself on the end of a polite telling-off and a warning. In others, you could find yourself in jail.

469 Photography in public places

The world is getting warier, and what used to be an accepted aspect of travel culture (e.g. vacation photos) has, in some places, become a reason for over-zealous officialdom. Beware of photographing any child who isn't your own, and expect at some landmarks to be accosted by a fellow in a uniform with a clipboard. Unless threatened with arrest (or a gun), never hand over your camera or memory cards to anyone.

470 Taking digital cameras on vacation

It is safe to pass a digital SLR and digital memory cards (e.g. your CompactFlash cards) through the X-ray devices at airports. If stowing equipment in the aircraft hold, pack it in a bag that doesn't shout "expensive camera gear–steal me." If using obvious camera cases, place them in an old satchel. US customs will break padlocks to check hold baggage, but there are special locks available to which Customs officials have special keys.

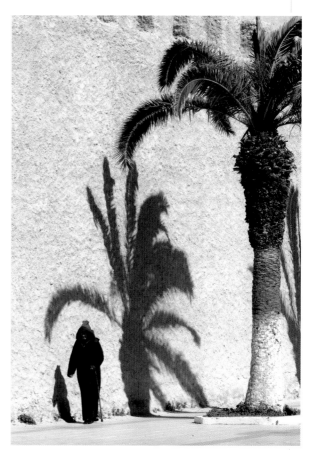

471 Personal safety and security

Be especially aware of your surroundings and the people around you. Tourists, particularly those carrying expensive digital cameras, can fall prey to the less honest factions of society. Keep vigilant, and try to stay within a group to avoid the worst that can happen.

Camera care

Preserving your gear

The build and durability of different cameras varies, depending on their specification. High-end professional-specification cameras are often designed to withstand heavy use in camera-hostile environments. They have metal body frames, durable coverings, and openings sealed to prevent penetration by dirt, dust, and moisture. At the opposite end of the scale, cameras may be designed only for light use, and certainly not in extreme environments.

 Use your camera wisely

Use your camera as it was intended. If you are considering a trip to the Antarctic, or into a rainforest, check to see whether your camera is built for it. If it isn't, get suitable protection, such as a rain cover.

 Avoid heavy knocks

Cameras today are computers, with all the intricate electronics that you would associate with your desktop PC or laptop. They need to be treated with care and, while most cameras will survive a slight knock or bump, they should be protected from harder impact.

 Cameras and the weather

Keep the camera dry and out of heavy rain. Also avoid exposing the camera to excessive heat and prolonged periods in direct sunlight.

475 Next time you visit a hotel...

Take the complimentary shower cap from the bathroom with you. They make excellent, lightweight rain covers for digital cameras.

476 The LCD screen

Keep the LCD screen cover attached, to prevent the screen from getting scratched.

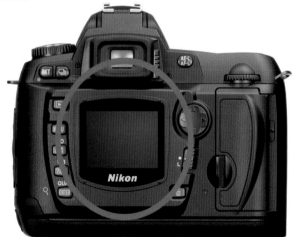

477 Changing lenses

Always turn off the camera when changing lenses to avoid excessive dust attaching to the sensor. Whenever possible, change lenses using a plastic bag to isolate the camera from the environment.

478 Cleaning the sensor

It is inevitable with digital photography that the sensor will become marked by dust and small particles of dirt. This will become apparent by marks on your images. The sensor, although covered by a filter, is extremely delicate and easily marked. Ideally, you should have the sensor cleaned by an authorized service center.

479 Self-cleaning options

A quick burst from a manual air blower will remove loosely attached dust particles. For the stickier stuff, there are some special self-cleaning solutions on the market. These include swabs or special brushes. They are relatively easy to use and, if done with care and adherence to the instructions, rarely cause damage to the sensor.

480 Storage

When storing the camera at home, always attach the caps to the camera body and lenses, if stored separately, and keep the camera in a cool, dry place.

481 Remove batteries

Remove batteries from the camera whenever you are storing it for long periods.

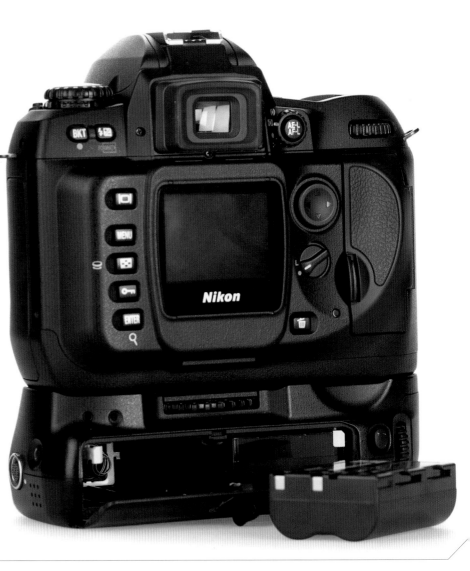

482 Never, never, never

Never use any type of cloth to clean the sensor, nor your finger. And don't even blow on it, as tiny drops of saliva can fall onto the sensor.

483 Switch off!

When exposing the sensor for cleaning, switch off the camera and use the special adaptor to raise the mirror and fire the shutter. Always refer to your user manual before attempting to clean the sensor.

484 Firmware upgrades

Most manufacturers provide upgrades to their DSLR cameras, in much the same way that software manufacturers provide updates to software packages without releasing a completely new version. These upgrades are known as firmware upgrades, and are released periodically, usually via the Internet. Watch for news on firmware upgrades on Web sites such as www.dpreview.com, as well as the manufacturer's own sites.

External devices

Digital peripherals
You may want to connect your camera to an external device to process images in-computer, print them, upload them to a Web site, send them via email, or even look at them on a TV. This section provides some hints and tips for connecting your camera to a computer or other electronic device.

485 Check the battery
Before connecting the camera to any external device, make sure the battery has sufficient charge to do the job.

486 Switch off
Always switch off the camera before connecting it to an external device.

487 Correct connection
Make sure you have connected correctly any cables between the camera and the external device.

488 Disconnecting
Always follow the manufacturer's instructions when disconnecting the camera. The disconnection process varies, depending on the equipment and the computer's operating system. Incorrectly disconnecting the camera can cause faults.

Computers

Computer software

Ensure the necessary software to view and edit your images is installed on the computer. If you shoot RAW files, this may be the manufacturer's proprietary software, as well as a package such as Photoshop Elements. If you never use the RAW file setting, and only ever shoot JPEGs, then most image-processing packages on the market will be suitable.

USB option

Depending on the software you are using, you may need to set the USB option in the menu options to either PTP or Mass Storage. Refer to your user manual.

Use a cardreader

A cardreader can be permanently connected to the computer, and avoids having to use the camera for downloading. Simply remove the memory card from your DSLR and plug it into the cardreader.

496 Cropping

You can crop images in-camera before printing them, printing only the area of the image that you want. This helps to remove distracting background objects but may reduce the quality of the print.

495 Print setup

As well as selecting which images to print, you can also specify other print parameters, such as print size, number of copies, whether a border is applied, and what information, if any, you want overlaid.

492 Printers

Some DSLR cameras can connect directly to a printer using a standard known as PictBridge. If this is the case with your camera, with an appropriate printer you will be able to print your photographs without having to use a computer.

493 Take JPEGs

For direct-to-printer printing, always take your images as JPEG files.

494 Single or multiple printing

Photographs can be printed either singly or as a batch. Refer to your user manual to manage the printing process.

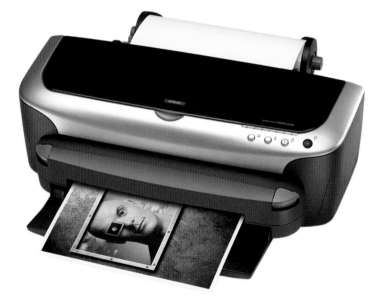

Televisions

As well as downloading your digital photographs to a computer, or printing them, you can show them in a slide show on a TV.

Get the right cable

You will need an appropriate video cable to connect the camera to the TV or VCR. This should be supplied in the box with the camera when bought new.

Set video mode

In the menu options, there will be a video mode setting. Set the video mode to match that of the device you are using: PAL for PAL devices, and NTSC for NTSC devices.

Tune the TV

The TV will need to be tuned to the video channel to display images from the camera.

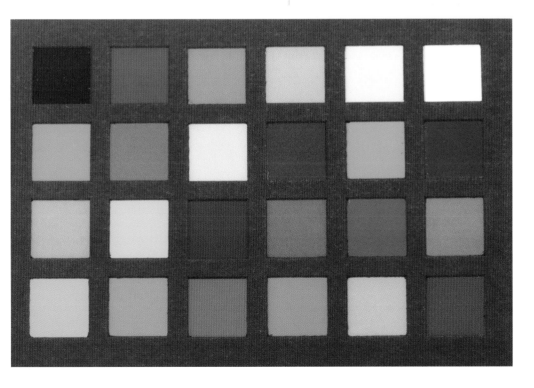

Technical Terms

Aperture

A variable opening inside a camera lens that lets light pass onto the CCD sensor. Aperture settings are arranged in an internationally recognized scale measured in f-numbers. These are typically arranged as follows: f/2.8, f/4, f/5.6, f/8, f/11, f/16, and f/22. Wider apertures such as f/2.8 let in the maximum amount of light compared to narrow apertures such as f/22, which let in the least amount.

Aperture priority (AP)

This is the most popular autoexposure option found in SLRs. Aperture priority works when the photographer defines the aperture value and the camera sets the right shutter speed to make a correct exposure. Aperture priority is useful when you want to create a particular depth of field effect.

Artifacts

Unfortunate by-products of digital image-processing that degrade image quality, visible as small marks, or pixels of incorrect value.

Autoexposure (AE)

When the camera automatically sets shutter speed and aperture value, so precise control over depth of field and movement cannot be guaranteed.

Autofocus (AF)

With this system, most compact cameras lock focus on the object in the center of your frame, which can cause a problem if your composition is off-center. Better SLRs have multizone autofocus systems, which can respond to more creative framing. Autofocus works best when locked onto an area with sufficient contrast.

Bit depth

Describes the size of color palette used to create a digital image. 8-bit, and 24-bit, are common palette sizes, creating 256, and 16.7 million colors, respectively. This is because there are 256 different combinations of ones and zeroes in a digital word that is eight characters long—e.g., 10111011—and 16.7 million permutations in a digital word that is 24 characters long. See Digital.

Bitmap image

A bitmap is a common term for a pixel-based image. Also called a raster image, this describes a grid of pixels arranged in a checkerboard-like arrangement.

Blu-Ray (Disk)

Emerging recordable DVD format that uses blue lasers, rather than the standard red lasers, to record data onto specially formatted disks. Blue light has a much shorter wavelength than red light, so Blu-Ray disks have larger storage capacities than standard DVDs. See also HD-DVD.

Blurring

Blurred images are frequently caused by unsteady hands moving the camera slightly during long exposures. The problem is more noticeable in low-light situations, but it is easily overcome by using a tripod to hold the camera steady while the shutter is open. Always use at least 1/125-second and 1/250-second exposures when using long telephoto lenses.

Bracketing

Used by professional photographers, bracketing is an insurance against uncertain exposure conditions. Instead of gambling on the success or otherwise of a single frame, several versions of the image are taken from the same viewpoint, each with a different exposure variation. After processing, the best frame for printing or reproduction can be selected.

Burning

A processing technique in which specific areas of the image are made lighter, for artistic effect.

Burst rate

The speed at which a camera can save and store image data, then ready itself to capture the next shot. In recent DSLRs, this is usually no longer a problem, but some older DSLRs are unable to shoot more than a few frames in rapid succession before pausing to process the data.

Calibration

The process of matching the characteristics or behavior of a device to a standard to ensure accuracy.

Card reader

A small device used to transfer memory card data to a computer. This kind of device is essential if your camera's image-upload software is incompatible with an older computer, or when faster data-transfer is desired from a camera, which has a slower serial port connector. Dual-format card readers accept both SmartMedia and CompactFlash cards.

CC filter

Color-correction filter. In film-based photography, color-correction filters can be used to match lighting color temperature with film stock. In digital photography, this function is generally carried out by the White Balance (WB) button.

CCD

Charge Coupled Device. This is one type of light-sensitive sensor used in place of film in a digital camera. A CCD is like a honeycomb of tiny individual cells, with each one creating an individual pixel.

CF card

CompactFlash memory card. A small, removable card on which can be stored up to one or more gigabytes of data, depending on the card's capacity. Photo-labs often accept these for running out prints.

CD-R

Compact Disk Recordable. For a long time CDs were the most cost-effective storage media used in digital photography, storing up to about 700MB of data at very little expense per disk. However, CDs' days are numbered since recordable DVDs have become affordable. New ultra-high-capacity DVDs will eventually dominate, such as Blu-Ray disks and HD-DVDs, offering as much storage potential on a single disk as some computers' internal hard disks.

CMOS (sensor)

Complementary Metal Oxide Semiconductor, an alternative type of photosensor to the CCD (Charge Coupled Device).

CMYK

Cyan, Magenta, Yellow, and Black is the four-color image mode used to prepare digital photographs for commercial lithographic printing. All magazines and books are printed with CMYK inks, which have a smaller color gamut (range) than the three-color RGB image mode used on computer monitors. In CMYK, "K" is sometimes regarded as being short for "key plate," which carries the black ink, although it is also regarded as being short for Black to avoid confusion with Blue.

Color casts

Color casts are unwanted tints or washes of color that can appear on your photographs. Casts are generally caused by shooting under an artificial light source such as domestic lightbulbs, or fluorescent tubes, without flash. Digital cameras have a built-in filtering system called the White Balance (WB) function, which compensates for the problem and adjusts the image once you have provided it with a white reference. This enables you to shoot under all lighting conditions with predictable results.

Color space

Different image modes such as RGB, CMYK, and LAB are designed with different color characteristics, called the color space. LAB is the largest color space, with RGB next, followed by the much smaller CMYK space. When converting images from a larger space to a smaller space, loss of original color can occur.

Color temperature

An exact measurement of light color, expressed using the Kelvin (k) scale.

Coma

An optical defect that degenerates the image-forming ability of a lens at the edge of the image space.

Compression

Crunching digital data into smaller files. Without physically reducing the pixel dimensions of an image, compression routines devise compromise color recipes for a larger group of pixels, rather than individual ones. JPEG is a commonly used compression routine.

Cropping

Images can be recomposed after shooting by a process called cropping. Digital photographers can use the Crop tool in Photoshop, Photoshop Elements, and other image-editing software packages to remove unwanted pixels.

CRT screen

Cathode Ray Tube, the standard type of computer monitor now being increasingly replaced by flat plasma screens and LCD technologies.

Depth of Field

The zone of sharpness set between the nearest and furthest parts of a scene. It is controlled by two factors: your position relative to the subject, and the aperture value. Higher f-numbers, such as f/22, create a greater depth of field than lower numbers, such as f/2.8.

Digital

In computerized devices, the method of storing and processing data as strings of binary code (ones and zeroes), millions of times per second in fast processors. In computer code, one represents "on" (or "voltage"), and zero represents "off" (or "no voltage"). 16-bit systems store data in binary sequences that are 16 characters long, 24-bit systems use sequences that are 24 characters long, and so on. The longer the binary word (the string of ones and zeroes), the more information is stored in it.

Dodge

Also called "holding back," dodging is a darkroom term for limiting exposure in small areas of an image. The technique can be imitated digitally in Photoshop and some other image-editing packages by selecting the Dodge tool, placing it over the desired area of the image, and holding down the mouse. The opposite effect/tool is Burn.

DPS

Digital Photo (or Pixel) Sensor, the general description of the different types of light-gathering sensors used by digital cameras.

DVD

Digital Versatile (or Video) Disk. High-capacity disks often used to store movies and other space-intensive media digitally. The recordable version, DVD-R, is increasingly used by photographers to store and archive their work.

Exposure

The amount of light that falls onto a digital sensor, or light-sensitive material. In both photographic printing and shooting, the exposure is controlled by a combination of time and aperture settings. The term is also commonly used by photographers to describe a single frame or shot taken.

Filters

In all photography, glass, plastic, or gelatin filters can be attached to a camera lens for adding different creative effects to a photograph. Filters work by absorbing or allowing through different wavelengths of light, thereby enabling some colors to pass through to the film while others are prevented from doing so.

FireWire

A high-speed protocol and computer connection for transferring large amounts of data quickly between two devices, such as a digital camera and a computer.

Flash

Electronic flash is calibrated to produce light of a consistent, neutral color. Flash is created when an electrical current passes through a tiny, gas-filled tube, which produces a rapid burst of light. Unlike other light sources, the light quality from a flash can't be seen before exposure.

F-Numbers

Aperture values are described in f-numbers, such as f/2.8 and f/16. Smaller f-numbers let more light onto your sensor, and bigger numbers less light.

FPS

Frames per Second. The number of images recordable by a digital camera within a one-second period.

Gamut

Gamut is a description of the range of a color palette used for the creation, display, or output of a digital image. Unexpected printouts often occur after CMYK mode images are prepared on RGB monitors and are said to be "out of gamut."

Gigabyte (Gb)

One gigabyte = one thousand megabytes. See Megabytes.

GIF

Graphics Interchange Format. A universal image format designed for monitor and network use only. Not suitable for saving photographic images due to the 256-color, 8-bit palette.

Grain

The gritty texture visible in enlargements made from fast film negatives. In digital photography, grain does not exist, although some see it as a desirable artifact of film photography. Filters for mimicking the effect of film grain are available in some image-editing packages.

Grayscale

In digital imaging, the grayscale mode is used to create and save black-and-white images. In a standard 8-bit Grayscale there are 256 steps from black to white, just enough to prevent banding visible to the human eye.

HD

The hard disk drive on a computer that serves as a computer's filing cabinet, also known simply as the hard disk.

HD-DVD

High-density DVD. Emerging DVD format, offering much greater storage capacities than standard DVDs, through the use of a blue laser. However, the format will be incompatible with most DVD recorders, and will create a format war with the competing Sony-backed Blu-Ray disks. See also Blu-Ray.

High resolution

High-resolution (or high-res) images are generally captured with many millions of pixels and are used to make high-quality printouts. Many pixels make a better job of recording fine detail compared to fewer pixels. High-res images can demand lots of storage space and need a computer with a fast processor to cope. Compressing high-res images makes file sizes smaller.

Histogram

A graphic representation of tonal range in an image.

Hyperfocal distance

The focus setting used to give maximum depth of field.

Ink-jet printer

A versatile output device used in digital imaging, which works by spraying fine droplets of ink onto media, such as paper.

Interpolation

All digital images can be enlarged by introducing new pixels to the bitmap grid. Called interpolation, images that have gone through this process never have the same sharp qualities or color accuracy as original non-interpolated images.

ISO / ISO-E

International Standards Organization. The ISO standard describes film and DPS speed. In film photography, the ISO value describes a film's ability to work under low or bright light conditions. For example, ISO 100 is a slow film suitable for the brightest light situations, ISO 200 and 400 are general-purpose films, while ISO 800, 1600, and above are for shooting in lowest light conditions. Digital cameras use the same system to describe ISO equivalency (ISO-E). Just like aperture and shutter speed scales, the doubling or halving of an ISO value halves and doubles the amount of light needed to make a successful exposure.

JPEG

An acronym for Joint Photographic Experts Group. JPEG files are a universal format used for compressing digital images. Most digital cameras save images as JPEG files to make more efficient use of limited capacity memory cards. The JPEG format is known as a "lossy" compression method as image quality deteriorates after resaving.

Macro

Macro is a term used to describe close-up photography. The lens itself determines how close you can focus and not all cameras are fitted with macro lenses as standard. Many mid-range zoom lenses offer an additional macro function, but much better results are gained by using specially designed macro lenses. When close focusing, effective depth of field shrinks to a matter of centimeters even when using narrow apertures like f/22.

Megabyte (Mb)

Units of memory or hard disk space on a computer.

Megapixel

A measurement of the maximum bitmap size a digital camera can create. A bitmap image measuring 1800x1200 pixels contains 2.1 million pixels (1800x1200=2.1 million), the maximum capture size of a 2.1 Megapixel camera. The higher the megapixel number, the bigger and better quality print out you can make.

Microdrive

IBM-designed memory card that is in fact a miniature removable hard-disk drive often used in digital cameras.

Noise

Similar to visible grain in conventional photographic film, digital noise occurs when shooting in low-light conditions or when a CCD sensor is used at a high ISO setting. When too little light falls onto the sensor, pixels are made in error. Most often red or green, these randomly arranged pixels are called noise and are found in dark and shadow areas of your photographs. Noise can be reduced—and added—in most image-editing packages, using a special filter.

Opening up

Opening up is a traditional photographic term that describes the act of setting a wider lens aperture, thereby opening the lens to allow more light to pass through to the sensor. Opening up is the opposite of stopping down.

Overexposure

This occurs when too much light is passed onto your light-sensitive material or digital sensor due to a miscalculated exposure. The result is pale, washed-out images.

Peripheral
An add-on to a computer, such as a scanner, printer, etc.

Photodiode
One of millions of light-sensitive cells in an electronic digital pixel sensor (DPS).

Photoshop
The industry-standard image-editing software program, made by Adobe.

Pixel
Short for "picture element," a pixel is the building block of a digital image like a single tile in a mosaic. Pixels are square in shape and arranged in a grid-like matrix called a bitmap.

RAM
Random Access Memory, which holds data during work in progress. Computers with little RAM will process images slowly as data is written to the slower hard drive. Extra RAM is easy to install.

RAW
A type of uncompressed picture file format that takes data directly off the digital sensor and stores it. Each make of camera will have its own proprietary RAW format.

Red eye
Image anomaly caused when on-camera flash is used to photograph people at close range. Red eye occurs when flash bounces back off the retina. Most SLRs have a red-eye reduction mode, which fires a tiny pre-flash to close down your subject's irises.

Scanner
A scanner is a tool for converting photographic film and prints into digital files, which can then be used on a computer. Flatbed scanners are shaped like small photocopiers and are used for capturing flat artwork by reflective light.

Shutter
All cameras are fitted with a shutter, either a thin curtain or series of blades that open and close to let light onto your film or digital sensor. Fast shutter speeds are used to capture fast-moving sports or action subjects, whereas slower shutter speeds are used to create deliberate blur or during very low light levels with a tripod.

Shutter-priority (mode)
Automatic exposure mode, where the user sets the shutter speed and the camera automatically sets the appropriate aperture for correct exposure—also known as shutter priority auto exposure.

Shutter release
The button you click to make an exposure, on DSLRs situated on the top right of the camera body.

SmartMedia Cards
A variety of small, removable memory card, on which can be stored varying amounts of data. Depending on the capacity of the card, this can be one gigabyte or more.

Stop
A common term used to describe a single shift of exposure along the aperture or shutter speed scale. When an exposure of f/8 at 1/60th of a second is changed to f/5.6 at 1/60th of a second, the result is an increase by one stop. Smaller shifts such as half or one-third of a stop can be set by using the exposure compensation dial.

Stopping down
The process of setting a smaller aperture to prevent excessive light from passing onto the sensor. It derives from traditional lenses, where aperture scales were presented as click stops on the lens barrel.

TIFF
Tagged Image File Format, the most common cross-platform image format. Compressed TIFFs use a lossless routine to retain image data.

TTL metering
Through-the-lens metering. Modern cameras use TTL metering for precise light measurements by reading the actual level of light that passes through the lens, rather than measuring the light levels outside it.

Underexposure
When not enough light reaches the sensor, underexposure occurs, creating images that look washed out.

USB
Universal Serial Bus, a common protocol and computer connection for sharing data quickly between compatible devices.

White Balance (WB)
A camera setting that overcomes color shifts caused by the different color temperatures of light.

INDEX

Acknowledgments

The author would like to thank RotoVision for the opportunity
and for making this book happen, especially Chris Middleton,
Tony Seddon, April Sankey, and Jane Waterhouse.

The publishers would like to thank Luke Herriott for the design.